The
VICTORIAN
Traveller's Guide TO
CAMBRIDGE

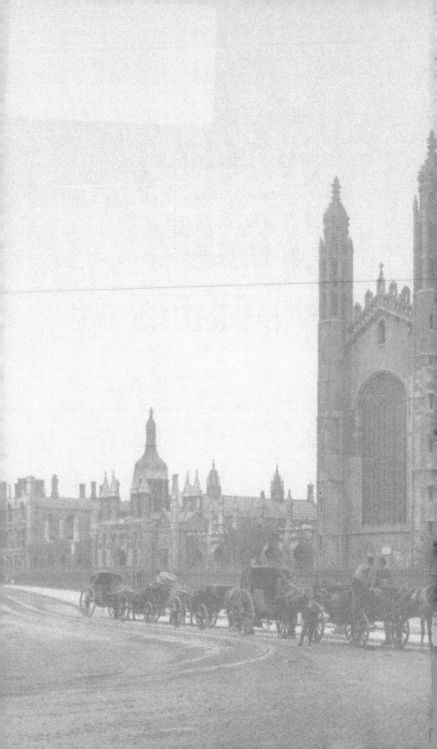

The VICTORIAN Traveller's Guide to CAMBRIDGE

GORDON HOME
& J. W. CLARK

AMBERLEY

Front cover image courtesy of the Library of Congress.

First published in 1901–10
This edition published 2014

Amberley Publishing
The Hill, Stroud
Gloucestershire, GL5 4EP

www.amberley-books.com

British Library Cataloguing in Publication Data.
A catalogue record for this book is available from the British Library.

ISBN 978 1 4456 4308 3 (print)
ISBN 978 1 4456 4324 3 (ebook)

Typesetting and Origination by Amberley Publishing.
Printed in the UK.

CONTENTS

	Map of 1900	6
Chapter I	Some Comparisons	9
Chapter II	Early Cambridge	13
Chapter III	The Medieval Town	21
Chapter IV	The Greater Colleges	43
Chapter V	The Lesser Colleges	71
Chapter VI	The University Library,	101
	The Senate House,	
	The Pitt Press, and	
	The Museums	
Chapter VII	The Churches in the Town	107
Chapter VIII	Social Life at Cambridge	113

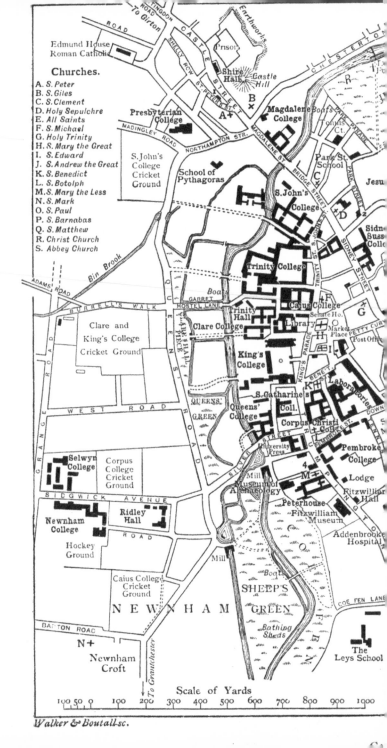

Churches.

A. *S. Peter*
B. *S. Giles*
C. *S. Clement*
D. *Holy Sepulchre*
E. *All Saints*
F. *S. Michael*
G. *Holy Trinity*
H. *S. Mary the Great*
I. *S. Edward*
J. *S. Andrew the Great*
K. *S. Benedict*
L. *S. Botolph*
M. *S. Mary the Less*
N. *S. Mark*
O. *S. Paul*
P. *S. Barnabas*
Q. *S. Matthew*
R. *Christ Church*
S. *Abbey Church*

Scale of Yards

100 50 0 100 200 300 400 500 600 700 800 900 1000

Walker & Boutall sc.

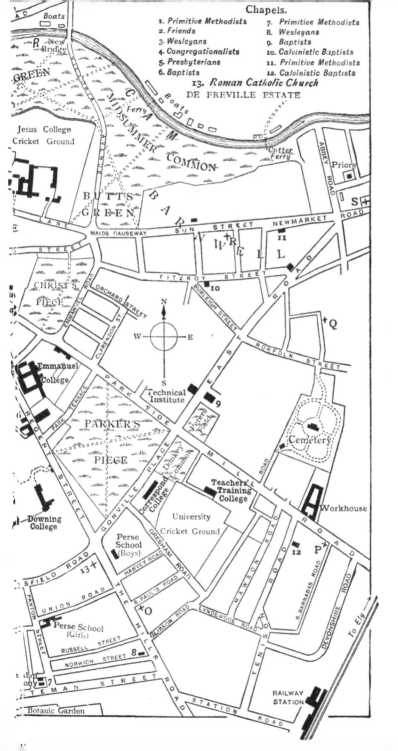

Chapels.

1. *Primitive Methodists*
2. *Friends*
3. *Wesleyans*
4. *Congregationalists*
5. *Presbyterians*
6. *Baptists*
7. *Primitive Methodists*
8. *Wesleyans*
9. *Baptists*
10. *Calvinistic Baptists*
11. *Primitive Methodists*
12. *Calvinistic Baptists*
13. *Roman Catholic Church*

SOME COMPARISONS

'...and so at noon with Sir Thomas Allen, and Sir Edward Scott and Lord Carlingford, to the Spanish Ambassador's, where I dined the first time.... And here was an Oxford scholar, in a Doctor of Laws' gowne.... And by and by he and I to talk; and the company very merry at my defending Cambridge against Oxford.'

Pepys' Diary (May 5, 1669).

In writing of Cambridge, comparison with the great sister university seems almost inevitable, and, since it is so usual to find that Oxford is regarded as pre-eminent on every count, we are tempted to make certain claims for the slightly less ancient university. These claims are an important matter if Cambridge is to hold its rightful position in regard to its architecture, its setting, and its atmosphere. Beginning with the last, we do not hesitate to say that there is a more generally felt atmosphere of repose, such as the mind associates with the best of our cathedral cities,

in Cambridge than is to be enjoyed in the bigger and busier university town. This is in part due to Oxford's situation on a great artery leading from the Metropolis to large centres of population in the west; while Cambridge, although it grew up on a Roman road of some importance, is on the verge of the wide fenlands of East Anglia, and, being thus situated off the trade-ways of England, has managed to preserve more of that genial and scholarly repose we would always wish to find in the centres of learning, than has the other university.

Then this atmosphere is little disturbed by the modern accretions to the town. On the east side, it is true, there are new streets of dull and commonplace terraces, which one day an awakened England will wipe out; there are other elements of ugly sordidness, which the lack of a guiding and controlling authority, and the use of distressingly hideous white bricks, has made possible, but it is quite conceivable that a visitor to the town might spend a week of sight-seeing in the place without being aware of these shortcomings. This fortunate circumstance is due to the truly excellent planning of Cambridge. It is not for a moment suggested that the modern growth of the place is ideal, but what is new and unsightly is so placed that it does not interfere with the old and beautiful. The real Cambridge is so effectively girdled with greens and commons, and college grounds shaded with stately limes, elms, and chestnuts, that there are never any jarring backgrounds to destroy the sense of

aloofness from the ugly and untidy elements of nineteenth-century individualism which are so often conspicuous at Oxford.

Cambridge has also made better use of her river than has her sister university; she has taken it into her confidence, bridged it in a dozen places, and built her colleges so that the waters mirror some of her most beautiful buildings. Further than this, in the glorious chapel Henry VI. built for King's College, Cambridge possesses one of the three finest Perpendicular chapels in the country–a feature Oxford cannot match, and in the church of the Holy Sepulchre Cambridge boasts the earliest of the four round churches of the Order of the Knights Templars which survive at this day.

But comparisons tend to become odious, and sufficient has been said to vindicate the exquisite charm that Cambridge so lavishly displays.

EARLY CAMBRIDGE

Roman Cambridge was probably called Camboritum, but this, like the majority of Roman place names in England, fell into disuse, and the earliest definite reference to the town in post-Roman times gives the name as Grantacaestir. This occurs in Bede's great Ecclesiastical History, concluded in A.D. 731, and the incident alluded to in connection with the Roman town throws a clear ray of light upon the ancient site in those unsettled times. It tells how Sexburgh, the abbess of Ely, needing a more permanent coffin for the remains of AEtheldryth, her predecessor in office, sent some of the brothers from the monastery to find such a coffin. Ely being without stone, and surrounded by waterways and marshes, they took a vessel and came in time to an abandoned city, 'which, in the language of the English, is called Grantacaestir; and presently, near the city walls, they found a white marble coffin, most beautifully wrought, and neatly covered with a lid of the

same sort of stone.' That this carved marble sarcophagus was of Roman workmanship there seems no room to doubt, and Professor Skeat regards it as clear that this ruined town, with its walls and its Roman remains, was the same place as the Caer-grant mentioned by the historian, Nennius.

In course of time the Anglo-Saxon people of the district must have overcome their prejudices against living in what had been a Roman city, and Grantacaestir arose out of the ruins of its former greatness. In the ninth century a permanent bridge was built, and the town began to be known as Grantabrycg, or, as the Anglo-Saxon Chronicle gives it, Grantebrycge. Domesday toned this down to Grentebrige, and that was the name of Cambridge when a Norman castle stood beside the grass-grown mound which is all that remains to-day of the Saxon fortress. What caused the change from G to C is hard to discover, but when King John was on the throne the name was written Cantebrige, and the 'm' put in its appearance in the earlier half of the fifteenth century, the 't' being discarded at the same period. It seems that the name of the river was arrived at by the same process. Perhaps the oddest feature of the whole of these vicissitudes in nomenclature is the similarity between the Roman Camboritum and Cambridge, for the two names have, as has been shown, no connection whatsoever.

A map of Cambridgeshire, compiled by the Rev. F.G. Walker, showing the Roman and British roads reveals instantly that the university town has a

Roman origin, for it stands at the junction of four roads, or rather where Akeman Street crossed Via Devana, the great Roman way connecting Huntingdon and Colchester. Two or three miles to the south, however, the eye falls on the name of a village called Grantchester, and if we had no archaeology to help us, we would leap to the conclusion that here, and not at Cambridge, was the ancient site mentioned by the earlier chroniclers. And this is precisely what happened. Even recent writers have fallen into the same old mistake in spite of the discovery of Roman remains on the site of the real Roman town, and notwithstanding the fact that the two roads mentioned intersect there. The trouble arose through the alterations in spelling in the name of the village of Granteceta, or, as it often appears in early writings, Gransete, but now that Professor Skeat has given us the results of his careful tracking of the name back to 1080, when it first appears in any record, we see plainly that this village has never had a past of any importance, and that the original name means nothing more than 'settlers by the Granta.' There is a Roman camp near this village, and a few other discoveries of that period have been made there, but such finds have been made in dozens of places near Cambridge.

It is therefore an established fact that modern Cambridge has been successively British, Roman, Saxon, and Norman, and the original town, situated on the north-western side of the river, has extended across the water and filled the space bounded on three sides by the Cam.

Being on the edge of the Fen Country, where the Conqueror found the toughest opposition to his completed sovereignty in England, the patch of raised ground just outside modern Cambridge was a suitable spot for the erection of a castle, and from here he conducted his operations against the English, who held out under Hereward the Wake on the Isle of Ely. In the hurried operations preceding the taking of the 'Camp of Refuge' in 1071, there was probably only sufficient time to strengthen the earthworks and to build stockades, but soon afterwards William erected a permanent castle of stone on this marsh frontier–a building Fuller describes as a 'stately structure anciently the ornament of Cambridge.' In her scholarly work on the town, Miss Tuker tells us how Edward III. quarried the castle to build King's Hall; how Henry VI. allowed more stone to be taken for King's College Chapel; and how Mary in 1557 completed the wiping out of the Norman fortress by granting to Sir Robert Huddleston permission to carry away the remaining stone to build himself a house at Sawston! Wherever building materials are scarce such things have happened, even to the extent of utilizing the stones of stately ruins for road-making purposes. It thus comes about that the artificial mound and the earthworks on the north side of it are as bare and grass-grown as any pre-historic fort which has not at any period known a permanent edifice.

Owing to its fairs, and particularly to the famous Stourbridge Fair, an annual mart of very great if uncertain antiquity, held near the town

during September, Cambridge at an early date became a centre of commerce, and it had risen to be a fairly large town of some importance before the Conquest. In the time of Ethelred a royal mint had been established there, and it appears to have recovered rapidly after its destruction by Robert Curthose in 1088, for it continued to be a mint under the Plantagenets, and even as late as Henry VI. money was coined in the town.

A bridge, as already stated, was built at Cambridge in the ninth century, but in 870, and again in 1010, the Danes sacked the town, and it would seem that the bridge was destroyed, for early in the twelfth century we find a reference to the ferry being definitely fixed at Cambridge, and that before that time it had been 'a vagrant,' passengers crossing anywhere that seemed most convenient. This fixing of the ferry, and various favours bestowed by Henry I., resulted in an immediate growth of prosperity, and the change was recognized by certain Jews who took up their quarters in the town and were, it is interesting to hear, of such 'civil carriage' that they incurred little of the spite and hatred so universally prevalent against them in the Middle Ages. The trade guilds of Cambridge were founded before the Conquest, and, becoming in course of time possessed of wealth and influence, some of them were enabled to found a college.

As England settled down under the Norman Kings, the great Abbey of Ely waxed stronger and wealthier, and in the wide Fen Country there also grew up the abbeys of Peterborough, Crowland,

Thorney, and Ramsey–all under the Benedictine rules. To the proximity of these great monasteries was due the beginning of the scholastic element in Cambridge, and perhaps the immense popularity of Stourbridge Fair, which Defoe thought the greatest in Europe, may have helped to locate the University there. Exactly when or how the first little centre of learning was established in the town is still a matter of uncertainty, but there seems to have been some strong influence emanating from the Continent in the twelfth century which encouraged the idea of establishing monastic schools. Cambridge in quite early times began to be sprinkled with small colonies of canons and friars, and in these religious hostels the young monks from the surrounding abbeys were educated. Mr A.H. Thompson, in his Cambridge and its Colleges, suggests that the unhealthy dampness of the fens would have made it very desirable that the less robust of the youths who were training for the cloistered life in the abbeys of East Anglia should be transferred to the drier and healthier town, where the learning of France was available among the many different religious Orders represented there.

In 1284 the first college was founded on an academic basis. This was Peterhouse. Its founder was Hugh de Balsham, Bishop of Ely, who had made the experiment of grafting secular scholars among the canons of St John's Hospital, afterwards the college. Finding it difficult to reconcile the difficulties which arose between secular and religious, he transferred his lay scholars, or Ely

clerks, to two hostels at the opposite end of the town, and at his death left 300 marks to build a hall where they could meet and dine. After this beginning there were no imitators until forty years had elapsed, but then colleges began to spring up rapidly. In 1324 Michael House was founded, and following it came six more in quick succession: Clare in 1326, King's Hall in 1337, Pembroke in 1347, Gonville Hall in 1348, Trinity Hall in 1350, and Corpus Christi in 1352. These constitute the first period of college-founding, separated from the succeeding by nearly a century.

The second period began in 1441 with King's, and ended with St John's in 1509. After an interval of thirty-three years the third period commenced with Magdalene, and concluded with Sidney Sussex in 1595. A fourth group is composed of the half-dozen colleges belonging to last century.

THE MEDIEVAL TOWN

When an antiquary examines a Cathedral which at first sight appears to present uniformity of design, he not unfrequently finds that the choir is of one period, the nave of another, the transepts of a third; all having been built long subsequently to the foundation of the primitive church, whose walls and piers must be disinterred from underneath the statelier additions of more recent times. Those who would trace the history of one of our populous towns are obliged to pursue much the same process. The fortifications have been pulled down long ago; half the churches have served as quarries out of which the other half have been built; and though an old name of a street may here or there survive, the primitive town is hidden away under the modern one as completely as is a hermit's cell beneath the Cathedral raised to commemorate his saintly life. A University town, however, though it has outgrown its ancient limits, and been modernised in diverse ways, is

less subject to change than almost any other. The colleges guard their territories with jealous care; they allow of no encroachment; they alienate no portion of the sacred soil, except on rare occasions to some other College, or to the University, for University purposes; and, moreover, they gradually acquire so much property in the town, that they can regulate, in some degree, the extent and direction of its development. Thus, though the colleges of Cambridge have been a good deal altered and enlarged since their first foundation, and even since 1690, as is proved by comparing the existing structures with David Loggan's engravings, taken shortly before that year — though some have even been entirely rebuilt; yet the ancient landmarks have not been obliterated. Time has dealt gently with them on the whole; revolution, notwithstanding all that has been said to the contrary, has hardly done them severer injury than the destruction of a Virgin's head or the defacement of a royal scutcheon; nay, even in regard of ordinary accidents, they have been singularly fortunate. In the words of Fuller:

'Whosoever shall consider in both Universities the ill contrivance of many chimneys, hollowness of hearths, shallowness of tunnels, carelessness of coals and candles, catchingness of papers, narrowness of studies, late reading and long watching of scholars, cannot but conclude that an especial providence preserveth those places. How small a matter hath sometimes made a partition betwixt the fire and the fuel? Thus an hair's breadth, fixed by a divine finger, shall prove as

effectual a separation from danger as a mile's distance. And although both Universities have had sad accidents in this kind, yet neither in number or nature (since the Reformation) so destructive as in other places: so that, blessed be God, they have been rather scare-fires than hurtfires unto them.'

If, however, the town of Cambridge has been, on the whole, but little altered by comparison with other places that have increased with equal rapidity, a more thorough change has been wrought in the neighbourhood in the last fifty years than in most other parts of England in five hundred. On the one hand, the open country has been enclosed; on the other, the Fen-land has been drained. Let us try to imagine the condition of this latter district in the Middle Age, when Cambridge was a frontier fortress on the edge of the great wild that then stretched away towards the north-east as far as the Wash. It was crossed by only one great Roman Way, the Akeman Street, which led from Cambridge to Brancaster; and even this carefully avoided the low grounds, passing from island to island with such skill in engineering that not more than nine miles of fen had to be traversed between Cambridge and the high ground of Norfolk. Right and left of this causeway stretched a sea of peat-moss, all but impassable except to those who were in the secret of its fords and by-ways, traversed by sluggish rivers, and dotted here and there with green islands, chief of which was the central eminence of Ely Isle, the holy hill of Etheldreda, the Camp of Refuge to which the Saxons fled

when they made their last deter-, mined resistance to the Norman invaders. Notwithstanding all its drawbacks — the agues and fevers that racked the inhabitants, the outlaws who plundered them, and the Danish invaders who could easily ascend the rivers, and burn and murder after their manner — the Fen-land must have had a beauty and interest of its own, such as is always to be found where Nature is left undisturbed, and bird, and beast, and insect multiply without the interference of man. It is all gone now. Two thousand square miles of the finest corn-land in England have replaced mere and reed-bed; the amphibious population of the fen — 'yellow-bellies,' as their neighbours of terra firma contemptuously styled them — have become opulent and portly farmers, so portly indeed that a big hole in a dyke, through which the water was pouring in a storm, defying all efforts to restrain it, is said to have been effectually stopped by the simple expedient of the farmer sitting down in it; and the soil that it was once thought impossible, if not impious, to drain, has now become so dry that in a certain hot summer a few years ago water had to be pumped into the Fen instead of out of it. Here and there, as in Wicken Fen, a few acres of primeval wilderness survive to give us some idea of what the rest once was. The ground where the marsh-fern still flourishes is sodden with black, unwholesome water; the sedge and the reeds are breast-high; and in summer-time the great swallow-tailed butterflies float lazily about as they did of old. However, as Kingsley said in his beautiful rhapsody on the Fens:

'We shall have wheat and mutton instead, and no more typhus and ague; and, it is to be hoped, no more brandy-drinking and opium-eating; and children will live and not die. For it was a hard place to live in, the old Fen, a place where one heard of "unexampled instances of longevity," for the same reason that one hears of them in savage tribes, that few lived to old age at all, save those iron constitutions which nothing could break down.'

No doubt the Fen was a hard taskmaster, and some of those who dwelt in it were not gentle either, for chains and collars to harness captives, and chains wherewith slaves were yoked as they worked, have been found in it; yet it had a bright side as well as a gloomy one, and parts of it were a very paradise of fertility. Here is a picture of the Isle of Ely, from the Liber EUensis, as it appeared in the eleventh century. The speaker is a French knight who has been taken prisoner by Hereward, and having been hospitably entertained by him, returns to William's camp and describes what he had seen:

'In our Isle men are not troubling themselves about the siege; the ploughman has not taken his hand from the plough, nor has the hunter cast aside his arrow, nor does the fowler desist from beguiling birds. If you care to hear what I have heard and seen with my own eyes, I will reveal all to you. The Isle is within itself plenteously endowed; it is supplied with various kinds of herbage; and in richness of soil surpasses the rest of England. Most delightful for charming fields and

pastures, it is also remarkable for beasts of chase; and is, in no ordinary way, fertile in flocks and herds. Its woods and vineyards are not worthy of equal praise; but it is begirt by great meres and fens as though by a strong wall. In this Isle there is an abundance of domestic cattle, and a multitude of wild animals; stags, roes, goats, and hares are found in its groves and by those fens. Moreover, there is a fair sufficiency of otters, weasels, and polecats; which in a hard winter are caught by traps, snares, or by any other device. But what am I to say of the kinds of fishes and of fowls, both those that fly and those that swim? In the eddies at the sluices of these meres are netted innumerable eels, large water- wolves, with pickerels, perches, roaches, burbots, and lampreys, which we call water-snakes. It is, indeed, said by many that sometimes salmon are taken there, together with the royal fish, the sturgeon. As for the birds that abide there and thereabouts, if you are not tired of listening to me, I will tell you about them, as I have told you about the reSt There are flue geese, teal, coots, didappers, water-crows, herons, and ducks, more than man can number, especially in winter or at moulting time. I have seen a hundred — nay, even three hundred — taken at once; sometimes by bird-lime, sometimes in nets or snares.'

This vast prodigality of life has perished with the morasses and the meres that sheltered it, and year by year, as drainage become more extensive and more thorough, the Cambridge market is more scantily furnished from the Fen. The stag, the roe, and the goat have been long extinct, and their existence is only revealed to us by the abundance

of their bones that are found in the all-preserving peat. Many another animal is proved by the same evidence to have once existed in the Fen, or near it; the gigantic aurochs, which, on the Continent, survived till the Lombard invasion of Italy; the smaller short-horned ox; the wild cat, marten, badger, otter, bear; and last, but not least, beaver, in sufficient abundance to show that there must have been numerous colonies of them there. The drainage of Whittlesea Mere, completed in 1850, destroyed the last home of one of the most remarkable of British insects, the great copper butterfly; and of many birds also. Snipe are said to breed no longer in the Fen; while ruffs and reeves, godwits, spoonbills, bitterns, and herons, are almost as much creatures of the past as the pelican, whose former existence is proved by a couple of his wingbones preserved in the Cambridge University Museum.

On the western edge of the Fen-land, where the higher ground terminates on the left bank of the Cam in an eminence of considerable height, stood the Roman station of Camboritum. This commanding position had already been taken possession of by an earlier race, as is shown by the lofty mound called Castle Hill, probably a British earth-work. This was included within the precincts of the Roman fortifications, traces of which can still be recognised. They measured about 1650 feet from north to south, by 1600 feet from east to weSt At this point the Akeman Street left the Fen, and was crossed, at almost right angles, by a second Roman Way, the Via

Devana, which ran from Colchester to Chester.
The situation of Camboritum, at the junction of
two such important roads, probably saved it from
the destruction which overtook so many Roman
towns in the havoc of the English conquest, and
caused it to be at once occupied by the conqueror.
It is not to Cambridge, therefore, but to some other
Roman station that Bede refers, when he relates
how Sexburga, sister of Etheldreda, foundress
of Ely, sent to seek a marble sarcophagus fit to
contain the saint's remains. 'The brethren whom
she sent,' says the historian, 'took ship and came to
a certain ruined town at no great distance, which
in the English tongue is called GrantacsBstir;
there presently they found, hard by the walls, a
white marble coffin, exquisitely wrought, with a
lid of the same material.' This description does
not suit Cambridge, where few Roman remains
have been discovered; but, on the other hand,
it suits Grantchester exceedingly well, a village
about three miles higher up the stream, where
there is a well-marked Roman encampment, and
where there was evidently an extensive cemetery,
for many ancient coffins may still be seen, built
into the walls of the church and churchyard. This
town was apparently early deserted in favour of
Camboritum, which, for the reasons mentioned
above, was the more convenient and important
station. Camboritum stood nearly opposite to the
northernmost limit of a considerable bend of the
river, which is crossed by a bridge at the bottom
of the hill commanded by the camp or castle. As
there is evidence that the road which passes over

this bridge is the southward extension of the Via
Devana, it is almost certain that the river has
always been crossed at the same place. In ancient
times fords were used instead of bridges, and, in
fact, in the middle of the last century, when the
bridge was being repaired, traces of a ford were
found in this place. It may therefore be suggested
that Camboritum signifies 'the ford (ritum) at the
bend,' a name derived from the position of the
high ground, which effectually commanded the
passage of the river.

 In the Middle Ages the name Camboritum
seems to have been either unknown or forgotten;
Grantebrigge or Cantebrigge is the only name in
use, while the river, if a name more distinct than
'the running water' is used for it, is called le Ee, or
le Rhee, a name which is still applied to the upper
part of its course. The name Granta reappears on
Saxton's map of Cambridgeshire (1576); and in
Spenser's Faery Queene (1590), under the form
Guant:

' Next these the plenteous Ouse came far from land,
By many a city and by many a towne, And many rivers
taking under-hand Into his waters, as he passeth
downe, (The Cle, the Were, the Guant, the Sture, the
Rowne), Thence doth by Huntingdon and Cambridge
flit; My mother, Cambridge, whom, as with a crowne,
He doth adorne, and is adorn'd of it With many a
gentle muse and many a learned wit.'

Camden, writing in 1586, recognises the Cam as
well as the Granta: 'By what name writers termed

this River, it is a question: some call it Chianta, others Camus' On Speed's map of Cambridgeshire (1610) the name Cam occurs alone, written twice, once above, and once below, Cambridge; Milton personifies it as a river-god in Lycidas (1638): 'Next Camus, reverend sire, went footing slow, His mantle hairy and his bonnet sedge, Inwrought with figures dim, and on the edge 'Like to that sanguine flower inscribed with woe'; and on Loggan's map of Cambridge (1688) the words The River Cam, are written out in full, without any other designation. On the other hand, so late as 1702, an Act of Parliament for improving the navigation speaks of the River Cham, alias the Grant. The usefulness of this stream to the inhabitants of Cambridge — whatever name they gave to it — was very great. Until the beginning of the seventeenth century it supplied them, to a great extent, with water for household use; and until the construction of railways it was the principal highway along which provender of all sorts, fuel, and heavy goods, were brought to the town. This explains the ill-feeling excited at different times as the colleges gradually acquired and closed up the lanes leading to it. We quote a graphic description of the advantages derived from the river which appears in a work called Cantabrigia Depicta, published in 1763. The name, it will be observed, is still The Grant.

'The Air of Cambridge is very healthful, and the Town plentifully supplied with excellent Water, not only from the River and Aqueduct already mentioned, but

from the numerous Springs on every Side of it; some of them medicinal. Nor is it better supplied with Water, than it is with other necessaries of Life. The purest Wine they receive by the Way of Lynn: Flesh, Fish, Wild-fowl, Poultry, Butter, Cheese, and all Manner of Provisions, from the adjacent country: Firing is cheap; Coals from Seven-pence to Nine-pence a Bushel; Turf, or rather Peat, four Shillings a Thousand; Sedge, with which the Bakers heat their Ovens, four Shillings per hundred Sheaves: These, together with Osiers, Reeds and Rushes used in several Trades, are daily imported by the River Grant. Great Quantities of Oil, made of Flax-Seed, Cole-Seed, Hemp and other Seeds, ground or pressed by the numerous Mills in the Isle of Ely, are brought up this River also; and the Cakes, after the Oil is pressed out, afford the Farmer an excellent Manure to improve his Grounds. By the River also they receive 1500 or 2000 Firkins of Butter every Week, from Norfolk and the Isle of Ely, which is sent by Waggons to London: Besides which, great quantities are made in the neighbouring Villages, for the Use of the University and Town, and brought fresh to Market every Day, except Monday. Every Pound of this Butter is rolled, and drawn out to a Yard in Length, about the Bigness of a Walking-Cane; which is mentioned as peculiar to this Place. The Fields near Cambridge furnish the Town with the best Saffron in Europe, which sells usually from 24 to 30 Shillings a Pound.'

On the site of Roman Camboritum William the Conqueror founded Cambridge Castle in 1068, on his return from the conquest of York; and in the

following year he took up his abode there while conducting the operations against Ely, where Hereward was commanding in person. At this time the town of Cambridge must have been almost entirely confined to the district round the Castle, still popularly called the Burgh or Borough; and before William came, it evidently occupied the site of the Roman station, for twenty-seven houses are said to have been destroyed by him to make way for the Castle. The fortifications were confined to the high ground, for it was clearly needless to guard even the passage of the river below. Danger was to be expected from the fen in front, not from the arable land behind, or from the open grass-covered Gogmagog Hills to the south-east, whence the great dyke, called 'Devil's Dyke,' stretched down to the river by Reche, at the entrance to Burwell Fen, a sure defence from assailants in that direction. The further history of the Castle is singularly uneventful. No deeds of arms are recorded in connection with it; it was never taken, nor, so far as we know, ever defended. In the first quarter of the fourteenth century part of it became a prison, and the rest was gradually pulled down. Edward the Third built his college of King's Hall with some of the materials; Henry the Fifth granted stone and timbers out of it for the erection of the chapel of the same; and in 1441 Henry the Sixth allowed the provost and scholars of King's College to make similar use of the hall and a chamber adjoining, then unroofed and ruinous. Notwithstanding these grants, the Keep is alluded to as still standing in 1553; and in 1642, when the Earl of Manchester

held Cambridge for the Parliament, it appears to have been easily put into an efficient state of defence, with the help of materials seized from Clare Hall, the rebuilding of which had been begun shortly before. We read of breastworks, and bulwarks, and strong fortifications. These were again demolished at the restoration of peace; but the Gate-house remained until 1842, but little altered from the appearance it presents in our woodcut, Which is copied from a view taken in 1773. The County Courts and the Gaol now occupy the site. The Castle Hill, unoccupied by buildings, is the occasional resort of sightseers, for the sake of the fine view to be obtained from it. It used to be a favourite joke to persuade 'freshmen' to mount it, in the hope of 'seeing the term divide,' an operation which they were led to believe was attended by certain solemn portents when the Cambridge Calendar announced that 'the term divides at midnight.' At its first origin, then, the town of Cambridge was limited to a few houses round the Castle, and along the street leading to and from the ford at the foot of the Castle Hill. The ford, it must be remembered, must always have been of great importance, for it was the only point at which merchandise and cattle could pass the river on their way from the Eastern Counties to the Midlands. It is conceivable, therefore, that even without the Norman stronghold, and without the University, a town might have grown up at this spot.

The origin of the University cannot be defined. It did not spring into being in any particular

year, or at the bidding of any particular founder; it grew up gradually, as a voluntary association of teachers and taught, governed by enactments framed by the body itself, and sanctioned or repealed from time to time. It used to be asserted that it owed its origin to the two great Benedictine monasteries of the Fen-land, Croyland and Ely; and we know that monks from the latter house did resort to Cambridge for study at a very early date. But they would hardly have gone out into the wilderness to found an institution for which Croyland or Ely would have afforded an equally suitable site; the fact that they came proves that schools must have been already in existence. More extended research in monastic archives may elicit further facts respecting the early connection of the great religious Orders with Oxford and Cambridge; for the present we will be content with the fact that we owe to the convent of Ely the establishment of the collegiate system at Cambridge. Bishop Hugh de Balsham, who before his promotion had been sub-prior of the convent, and may have been a student in the schools of Cambridge, unquestionably founded Peterhouse in 1284.

By the end of the thirteenth century the town of Cambridge had outgrown the narrow limits that were sufficient for it when the Castle was built, and had extended itself over the level ground on the opposite side of the river, to the right and left of the Roman road, the course of which is marked by the long straight street that runs through Cambridge from north to south, and is called

Bridge Street, Sidney Street, and St Andrew's Street, in different parts of its course. Nearest to the Castle, on the right of the street, stood the Hospital of St John, founded, in all probability, by John Frost, a burgher of Cambridge, — though subsequently the Bishops of Ely, as Baker, the historian of St John's, says, 'set up for founders and patrons' of it. Into this corporation of regular canons Hugh de Balsham introduced certain secular scholars, under the idea that they would become 'one body and one college' {unum corpus et unum collegium), and miade due provision for their maintenance independently of the brethren. The intention was excellent, the result a failure. The two sets of occupants of the house quarrelled bitterly from the first, ' the scholars being perhaps too wise, and the brethren possibly over-good,' so that they had to be separated. The scholars were removed to the very opposite end of Cambridge, where lodging was found for them outside the town, in two hostels hard by a church then called St Peter's, which they were permitted to use as their chapel. In order to give an idea of what Cambridge was at this time, let us imagine one of these scholars, on his way from Ely to Cambridge, to ascend the Castle Hill, and let us try to realise the view spread out before him. The town was at that time rather like a pear in shape, of which the stalk would be represented by the Bridge, a wooden structure of many arches. The west side was bounded by the river; the east and south by the King's Ditch, constructed by Henry the Third for the defence of the town. It left the river just

above Queens' College, and returned to it below
the Great Bridge. The Roman Way ran close to
the eastern limit of the town, at no great distance
from the Ditch. About two hundred yards
from the Bridge a second street branched off to
the right, dividing the town into nearly equal
divisions. This, the present Trumpington Street,
was then called High Street, or High Ward. At the
point where it branched off, on the left of Bridge
Street, stood one of the four circular churches
in England, probably even then of considerable
antiquity, called St Sepulchre's. Round it clustered
the Jewry, a quarter of considerable extent, for it
stretched along the eastern side of High Street far
enough to include All Saints' Church. Opposite
to this church stood the Hospital of St John,
with extensive gardens and fish-ponds behind
it. Beyond the Hospital, to the south, there was
a dense network of narrow lanes, with here and
there a garden, or a vineyard, or a wharf along
the river bank, separating the compact masses
of dwelling-houses which extended as far as the
Carmelite Friary at the south-west angle of the
town. Close to this the High Street crossed the
King's Ditch by a bridge, to the north of which was
Trumpington Gate, perhaps a fortified structure,
as the other gates of the town may also have
been. Outside this gate, at the commencement of
a straggling suburb, stood the Church of St Peter,
in the midst of an extensive graveyard. Beyond it
was the House of the Brethren of the Penance, or
Penitence, of Jesus Christ, otherwise called 'Friars
of the Sack'; opposite to which, on the other

side of the street, was that of the White Canons of Sempringham. Had the eyes of our imaginary spectator followed the line of the boundary ditch, which must have been well marked by the broad band of unoccupied ground — a sort of boulevard — that extended along it, he would have seen the then newly-built House of the Augustinian Friars, with the extensive garden ground behind it, which became the Botanic Garden in the last century. Further to the east again, on the left of the Roman Way was the House of Dominicans, or Black Friars, after whom that portion of the street was afterwards called 'Preachers' Street.' At that time the House was probably unfinished, but in later days it became an extensive pile of buildings, with a lofty church. The outline of the nave may still be traced within Emmanuel College, whose founder, Sir Walter Mildmay, in contempt of the old religion, boasted that he had turned the Friars' church into a dining-hall, and their refectory into a chapel. Between this and the Round Church was the Franciscan House, which even then was probably extensive, but which afterwards possessed a spacious church, which Ascham described as an ornament to the University, and of which the foundations in Fuller's time could still be traced within the precincts of Sidney Sussex College. At the Reformation the University tried to obtain a grant of it, but without success. The solid walls were gradually destroyed to build other structures, as the items, 'stone from the Grey Friars,' in the accounts of more than one college, conclusively show. These monastic

buildings, except the Dominican Friary, stood close to the outskirts of the little town, but still within the preciucts. Beyond them were spacious commons, Cow Fen or Coe Fen, on the west; then Saint Thomas' Leas; and lastly, the Green-croft, which extended almost from the Great Bridge to the neighbouring village of Barnwell. In the midst of it, walled about, and overshadowed by trees, stood the Benedictine nunnery of St Rhadegund, afterwards Jesus College; while Barnwell would be rendered conspicuous by the great Priory Church of St Giles.

Let us return for a moment to the Church of the Holy Sepulchre, of which we illustrate the exterior and the interior. It is reputed to be the oldest of the English round churches, and to have been consecrated in 1101, though its origin and history are alike unknown. It consists of two distinct portions; the ancient round church, and the modern chancel and aisles. This latter portion was built in 1844, when the church — then in a dilapidated and almost ruinous condition — was saved from destruction by the ill-fated Cambridge Camden Society. The late Decorated style was selected by the architect, Mr Salvin, because there appeared to be evidence that the building which it replaced had been originally constructed during that period. It once contained the famous stone altar, to eject which a decree of the Court of Arches was found necessary. The details of that bitter controversy which, for the time, divided the University into two hostile camps, are not worth reviving. The Society became the object of

virulent, and most unjust, attacks, and after the secession of the Bishops and most of the principal University dignitaries, headed by the Chancellor, it was removed to London, where it flourished for many years under a new name.

The round portion, which, with the addition of, perhaps, a small apsidal chancel, was the entire original structure, is forty-one feet in diameter. It is composed of a central area, nineteen feet in diameter, surrounded by an aisle, to which access is obtained through eight massive round arches, resting on cylindrical piers. These support a clerestory, forming a low round tower, to which an upper storey was added in the fifteenth century to be used as a belfry. The weight of this addition nearly ruined the older work beneath it, which was further damaged and disfigured by the introduction of a gallery, and the liberal use of whitewash, while the floor beneath was obstructed by numerous pews of various shapes and sizes. The original round-headed windows had, with one exception, been replaced by Perpendicular insertions, and the picturesque porch was concealed beneath a tasteless penthouse of wood. These inappropriate additions were removed in the course of the restoration, the ancient walls were strengthened by a bed of concrete inserted beneath them, and the tower secured by iron bands. The round-headed windows were restored after the pattern of the one remaining, and the tower surmounted by an appropriate conical cap covered with grey Northamptonshire slates. The interior was cleared of the vulgar and unsuitable

fittings, and properly repaired. It remains as a vestibule to the modern chancel, being from its shape unsuitable for the reception of seats.

In our imaginary survey of Cambridge, another ancient building, probably the oldest in the town, has been omitted, the Church of St Benedict. It stood a little to the west of the House of the Augustinian Friars; and the archaic style of its architecture suggests that it was once the church of an independent village, which was standing on the low ground before the erection of the Norman stronghold on the hill beyond the river. Modern restoration has left hardly a fragment of this early church except the square west tower, of which the upper stage is shown in our woodcut. This remarkable monument has been described with much minuteness by the Rev. D. J. Stewart, from whom the following passage is borrowed:

'The walls are about three feet thick, constructed throughout of rough stone-work, and strengthened at the quoins externally by thin blocks of hewn stone laid flat and set up on their ends in regular alternate courses – an arrangement to which the name of "long-and-short work" has been given. It consists of three storeys, the lowest of which takes up about one-half of the whole building, and is finished by a plain projecting string-course. Tlie second storey is somewhat smaller than the lower one on which it stands, and is separated from the third by another rude string-course. This latter storey has not been much meddled with. In the middle of each of the four sides there is a window, divided by a central baluster ornamented with a band

of rudely carved rings, standing in the middle of the thickness of the wall, and supporting a large stone, or flat abcicus, which extends completely through the wall, and from which spring two semicircular window-heads cut out of a single stone. On each side of this central window there is a small one of the plainest kind, with a semicircular head, wrought out of a single stone. These small windows do not range with the middle one; their sills do not come down to the string-course; their heads are higher, and above each, with a single exception, there is a small block of stone, whose length is about twice its width, pierced through with a round hole.'

The tower is connected with the body of the church by a round-headed arch, plain and massive, with capitals adorned with rudely-carved representations of animals, characteristic of early work. Of the church that once existed coeval with the tower only a few fragments remain, built here and there into more modern walls. The present nave is of the thirteenth century, and the chancel, of which the east end is shown in our etching, was built in 1872. The building, of nearly equal height, abutting against the south side of the chancel, contained originally an upper and lower chapel, for the use of the students of Corpus Christi College. The former was used as a lecture-room as well as a chapel, a custom almost universal in colleges until the end of the seventeenth century. In the north wall there was a window looking into the parish chancel. This building is connected with the college by a picturesque gallery, beneath

which is a four-centred archway. This was the original churchway for the parishioners, who entered the nave of their church through a porch, now destroyed, at the west end of the south aisle. The chapel and gallery were erected by Dr Cosyn, Master of Corpus Christi College, between 1487 and 1515.

THE GREATER COLLEGES

ST JOHNS

With its three successive courts and their beautiful gateways of mellowed red brick, St John's is very reminiscent of Hampton Court. Both belong to the Tudor period, and both have undergone restorations and have buildings of stone added in a much later and entirely different style. Across the river stands the fourth court linked with the earlier buildings by the exceedingly beautiful 'Bridge of Sighs.'

To learn the story of the building of St John's is a simple matter, for the first court we enter is the earliest, and those that succeed stand in chronological order,–eliminating, of course, Sir Gilbert Scott's chapel and the alterations of an obviously later period than the courts as a whole.

To Lady Margaret Beaufort, the foundress of the college, or, more accurately, to her executor, adviser and confessor, John Fisher, Bishop of

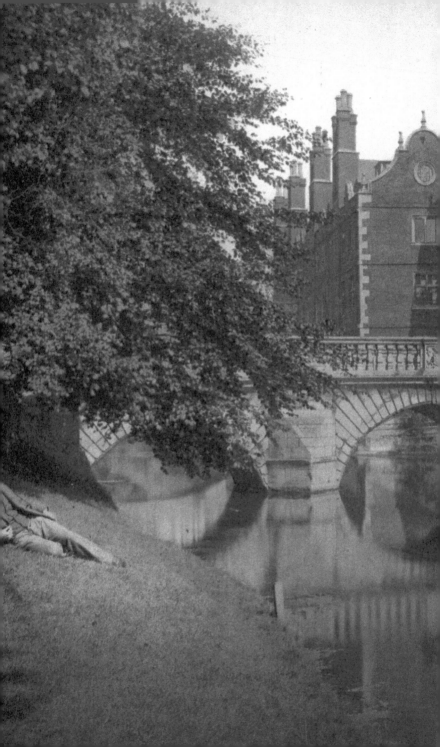

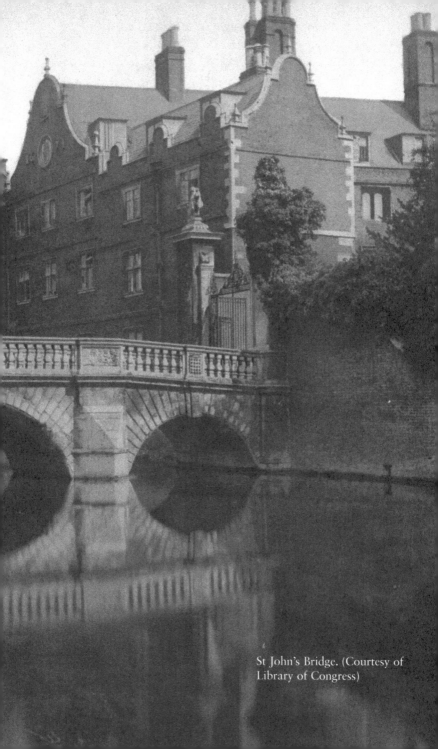

St John's Bridge. (Courtesy of
Library of Congress)

Rochester, who carried out her wishes, we owe the first court, with its stately gateway of red brick and stone. It was built between 1511 and 1520 on the site of St John's Hospital of Black Canons, suppressed as early as 1509.

The second court, also possessing a beautiful gate tower, was added between 1595 and 1620, the expense being mainly borne by Mary Cavendish, Countess of Shrewsbury, whose statue adorns the gateway. Filling the space between the second court and the river comes the third, begun in 1623, when John Williams, then Lord Keeper and Bishop of Lincoln, and afterwards Archbishop of York, gave money for erecting the library whose bay window, projecting into the silent waters of the Cam, takes a high place among the architectural treasures of Cambridge. If anyone carries a solitary date in his head after a visit to the University it is almost sure to be 1624, the year of the building of this library, for the figures stand out boldly above the Gothic window just mentioned. The remaining sides of the third court were built through the generosity of various benefactors, and then came a long pause, for it was not until after the first quarter of the nineteenth century had elapsed that the college was extended to the other side of the river. This new court came into existence, together with the delightful 'Bridge of Sighs,' between the years 1826 and 1831, when Thomas Rickman, an architect whose lectures and published treatises had given him a wide reputation, was entrusted with the work. The new buildings were not an

artistic success, in spite of the elaborate Gothic cloister, with its stupendous gateway and the imposing scale of the whole pile. Their deficiencies might be masked or at least diminished if ivy were allowed to cover the unpleasing wall spaces, and perhaps if these lines are ever read by the proper authority such a simple and inexpensive but highly desirable improvement will come to pass.

The stranger approaching St John's College for the first time might be easily pardoned for mistaking the chapel for a parish church, and those familiar with the buildings cannot by any mental process feel that the aggressive bulk of Sir Gilbert Scott's ill-conceived edifice is anything but a crude invasion. More than half a century has passed since this great chapel replaced the Tudor building which had unluckily come to be regarded as inadequate, but the ponderous Early Decorated tower is scarcely less of an intrusion than when its masonry stood forth in all its garish whiteness against the time-worn brick of Lady Margaret Beaufort's court. A Perpendicular tower would have added a culminating and satisfying feature to the whole cluster of courts, and by this time would have been so toned down by the action of weather that it would have fallen into place as naturally as the Tudor Gothic of the Houses of Parliament has done in relation to Westminster Abbey. Like Truro Cathedral, and other modern buildings imitating the Early English style, the interior is more successful than the exterior; the light, subdued and enriched by passing through the stained glass of the large west window (by

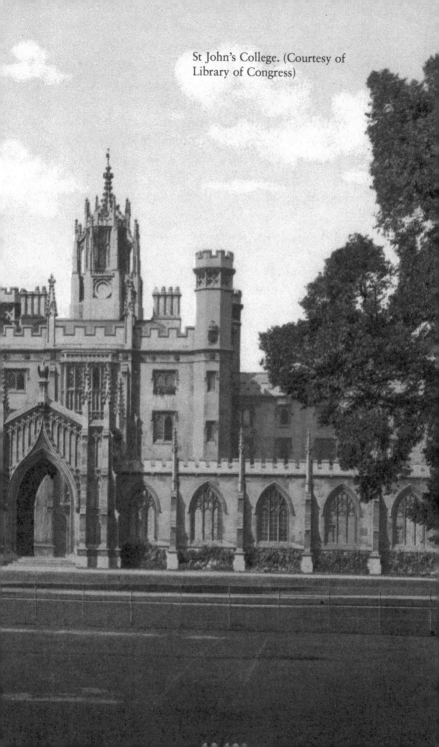

St John's College. (Courtesy of
Library of Congress)

Clayton and Bell) and others of less merit, tones down the appearance of newness and gives to the masonry of 1869 a suggestion of the glamour of the Middle Ages. Fortunately, some of the stalls with their 'miserere' seats were preserved when the former chapel was taken down, and these, with an Early English piscina, are now in the chancel of the modern building. The Tudor Gothic altar tomb of one of Lady Margaret's executors– Hugh Ashton, Archdeacon of York–has also been preserved.

At the same time as the chapel was rebuilt, Sir Gilbert Scott rebuilt parts of the first and second courts. He demolished the Master's Lodge, added two bays to the Hall in keeping with the other parts of the structure, and built a new staircase and lobby for the Combination Room, which is considered without a rival in Cambridge or Oxford. It is a long panelled room occupying all the upper floor of the north side of the second court and with its richly ornamented plaster ceiling, its long row of windows looking into the beautiful Elizabethan court, its portraits of certain of the college's distinguished sons in solemn gold frames, it would be hard to find more pleasing surroundings for the leisured discussion of subjects which the fellows find in keeping with their after-dinner port. There is an inner room at one end, and continuing in the same line and opening into it, so that a gallery of great length is formed, is the splendid library, built nearly three centuries ago and unchanged in the passing of all those years.

The library of St John's is rich in examples of early printing by Caxton and others whose books come under the heading of incunabula, but it would have been vastly richer in such early literature had Bishop Fisher's splendid collection–'the notablest library of books in all England, two long galleries full'–been allowed to come where the good prelate had intended. When he was deprived, attainted, and finally beheaded in 1535 for refusing to accept Henry as supreme head of the Church, his library was confiscated, and what became of it I do not know. Over the high table in the hall, a long and rather narrow structure with a dim light owing to its dark panelling, hangs a portrait of Lady Margaret Beaufort, the foundress of the college, and on either side of this pale Tudor lady are paintings of Archbishop Williams, who built the library, and Sir Ralph Hare. The most interesting portraits are, however, in the master's lodge, rebuilt by Sir Gilbert Scott on a new site north of the library.

It was through no sudden or isolated emotion that Lady Margaret was led to found this college in 1509, the year of her death, for she had four years earlier re-established the languishing grammar college, called God's House, under the new name of Christ's College, and had been a benefactress to Oxford as well. On the outer gateways of both her colleges, therefore, we see the great antelopes of the Beauforts supporting the arms of Lady Margaret, with her emblem, the daisy, forming a background. Sprinkled freely over the buildings, too, are the Tudor rose and the Beaufort portcullis.

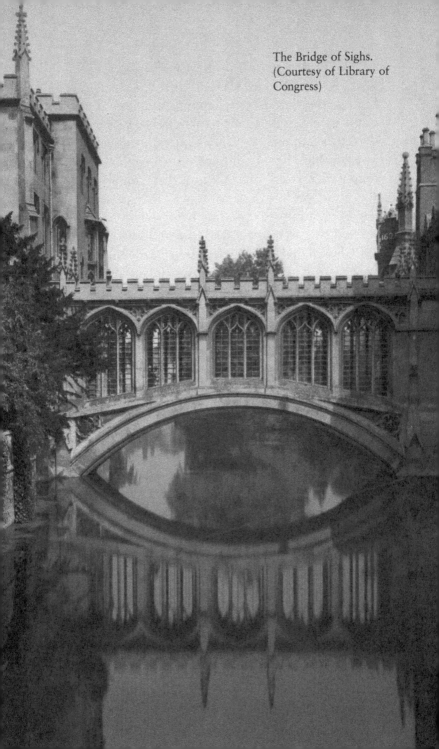

The Bridge of Sighs.
(Courtesy of Library of
Congress)

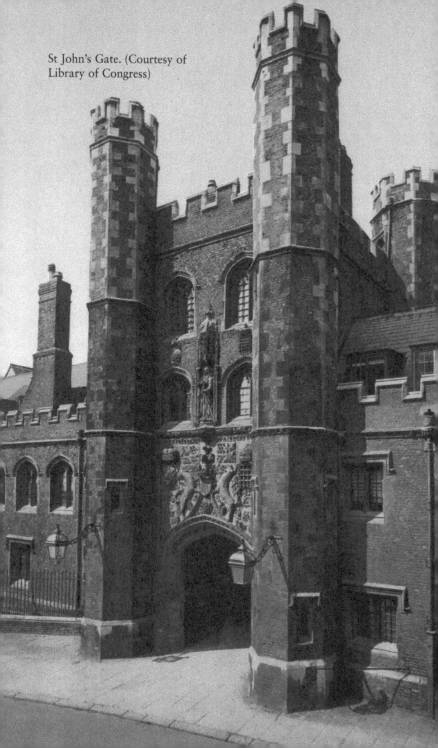

St John's Gate. (Courtesy of
Library of Congress)

St John's Hospital, which stood on the site of the present college, had been founded in 1135, and was suppressed in 1509, when it had shrunk to possessing two brethren only. The interest of this small foundation of Black Canons would have been small had it not been attached to Ely, and through that connection made the basis of Bishop Balsham's historic experiment already mentioned.

The founding of St John's by a lady of even such distinction as the mother of Henry VII. could not alone have placed the college in the position it now occupies: such a consummation could only have been brought about by the capacity and learning of those to whom has successively fallen the task of carrying out her wishes, from Bishop Fisher down to the present time. To mention all, or even the chief, of these rulers of the college is not possible here, and before saying farewell to the lovely old courts, we have only space to mention that among the famous students were Thomas Wentworth, Earl of Strafford, Lord-Lieutenant of Ireland; Matthew Prior, the poet-statesman; William Wilberforce, and William Wordsworth.

KINGS COLLEGE

Henry VI. was only twenty when, in 1441, he founded King's College. In that year the pious young Sovereign himself laid the foundation stone, and five years later it is believed that he performed the same ceremony in relation to the

chapel, which grew to perfection so slowly that it was not until 1515 that the structure had assumed its present stately form.

It was Henry's plan to associate his college at Eton, which he founded at the same time, with King's. The school he had established under the shadow of his palace at Windsor was to be the nursery for his foundation at Cambridge in the same fashion as William of Wykeham had connected Winchester and New College, Oxford. Henry's first plan was for a smaller college than the splendid foundation he afterwards began to achieve with the endowments obtained from the recently-suppressed alien monasteries. Had the young King's reign been peaceful, there is little doubt that a complete college carried out on such magnificent lines as the chapel would have come into being; but Henry became involved in a disastrous civil war, and his ambitious plans for a great quadrangle and cloister, three other courts, one on the opposite side of the river connected with a covered bridge and an imposing gate tower as well, never came to fruition. Fortunately, Henry's successor, anxious to be called the founder of the college, subscribed towards the continuance of the chapel, but he also diverted (a mild expression for robbery) a large part of Henry's endowments. Richard III., in his brief reign, found time to contribute £700 to the college, but it was not until the very end of the next reign that Henry VII., in 1508, devoted the first of two sums of £5,000 to the chapel, so that the work of finishing the building could go

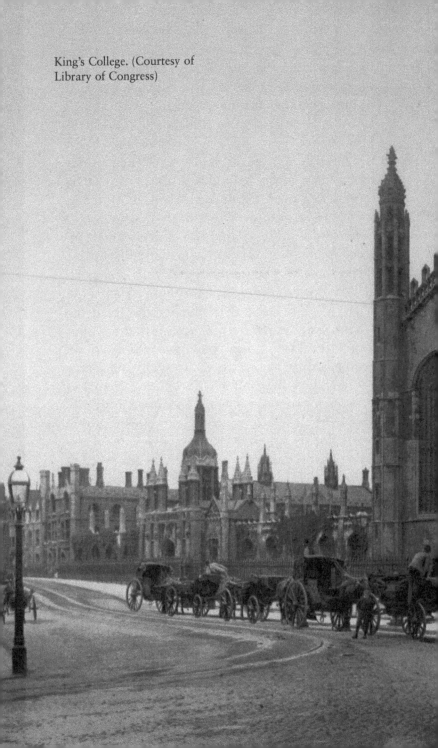

King's College. (Courtesy of
Library of Congress)

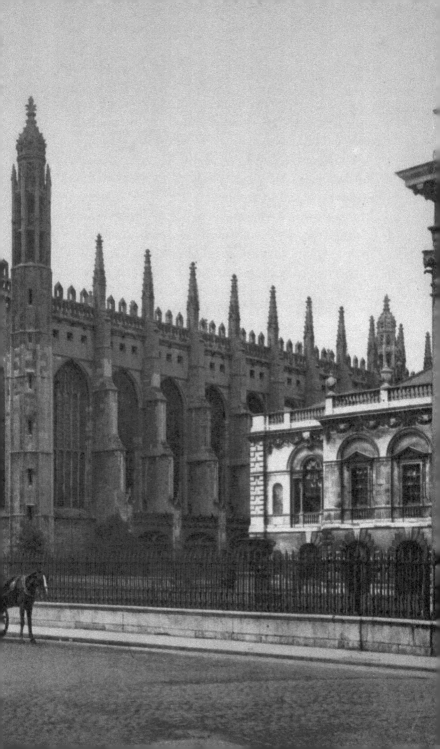

forward to its completion, which took place in 1515.

At the present time the chapel is on the north side of the college, but when originally planned it stood on the south, for the single court which was built is now incorporated in the University Library, and the existing buildings, all comparatively modern, stand in somewhat disjointed fashion to the south, and extend from King's Parade down to the river. Fellows' Building, the isolated block running north and south between the chapel and this long perspective of bastard Gothic, was designed by Gibbs in the first quarter of the eighteenth century, and its severe lines, broken by an open archway in the centre, are a remarkable contrast to the graceful detail, of the chapel. Framed by the great arch, there is a delicious peep of smooth lawn sloping slightly to the river, with a forest-like background beyond.

In the other buildings of King's it is hard to find any interest, for the crude Gothic of William Wilkins, even when we remember that he designed the National Gallery, St George's Hospital, and other landmarks of London, is altogether depressing. Even the big hall, presided over by a portrait of Sir Robert Walpole, is unsatisfying. It is the custom to scoff at the gateway and stone arcading Wilkins afterwards threw across the fourth side of the grassy court of the college; but, although its crocketed finials are curious, and we wonder at the lack of resource which led to such a mass of unwarranted ornament, it is not aggressive, neither does it jar with the academic repose of King's Parade.

Owing to the extreme uniformity of the exterior of the chapel the eye seems to take in all there is to see in one sweeping vision, refusing subconsciously to look individually at each of the twelve identical bays, each with its vast window of regularly repeated design. But there are some things it would be a pity to pass over, for to do so would be to fail to appreciate the profound skill of the mediaeval architects and craftsmen who could rear a marvellous stone roof upon walls so largely composed of glass. In this building, like its only two rivals in the world–St George's Chapel at Windsor Castle and Henry VII.'s Chapel at Westminster–the wall space between the windows has shrunk to the absolute minimum; in fact, nothing is left beyond the bare width required for the buttresses, and to build those reinforcements with sufficient strength to take the thrust of a vaulted stone roof must have required consummate capacity and skill. At Eton, where, however, the stone roof was never built, the buttresses planned to carry it appear so enormous that the building seems to be all buttress, but here such an impression could never for a moment be gained, for the chapel filling each bay completely masks the widest portion of the adjoining buttresses. The upper portions are so admirably proportioned that they taper up to a comparatively slight finial with the most perfect gradations.

Directly we enter the chapel our eyes are raised to look at the roof which necessitated that stately row of buttresses, but for a time it is hard to

think of anything but the splendour of colour and detail in this vast aisleless nave, and we think of what Henry's college might have been had the whole plan been carried out in keeping with this perfect work. Wordsworth's familiar lines present themselves as more fitting than prose to describe this consummation of the pain and struggle of generations of workers since the dawn of Gothic on English soil:

Tax not the royal Saint with vain expense,
With ill-matched aims the architect who planned–
Albeit labouring for a scanty band
Of white-robed Scholars only–this immense
And glorious work of fine intelligence!
Give all thou canst; high heaven rejects the lore
Of nicely-calculated less or more;
So deemed the man who fashioned for the sense
These lofty pillars, spread that branching roof
Self-poised, and scooped into ten thousand cells,
Where light and shade repose, where music dwells
Lingering–and wandering on as loth to die;
Like thoughts whose very sweetness yieldeth proof
That they were born for immortality.

When the sunlight falls athwart the great windows the tracery and the moulded stonework on either side are painted with 'the soft chequerings' of rainbow hues, and the magnificent glass shows at its best all its marvellously fine detail, as well as the beauty of its colour. The whole range of twenty-six windows having been executed under two contracts, dated 1516 and 1526,

there was opportunity for carrying out a great subject scheme, and thus it was found possible to illustrate practically the whole Gospel story, culminating in the Crucifixion in the east window, and continuing into apostolic times until the death of the Virgin Mary. At the west end is the one modern window. It represents the Last Judgement. It is safe to say that of their period this glorious set of windows has no real rival, and it is hardly possible to do them any justice if the visitor has become a little jaded with sight-seeing. In one of the windows there is a splendidly drawn three-masted ship of the period (Henry VIII.'s reign), high in the bow and stern, with her long-boat in the water amidships, and every detail of the rigging so clearly shown that the artist must have drawn it from a vessel in the Low Countries or some English port. It is one of the best representations of a ship of the period extant. This is merely an indication of the vivid archaeological interest of the glass, apart from its beauty in the wonderful setting of fan vaulting and tall, gracefully moulded shafts.

The splendid oaken screen across the choir, dividing the chapel into almost equal portions, was put up in 1536, at the same time as nearly the whole of the stalls. It is rather startling to see the monogram of Henry VIII. and Anne Boleyn, entwined with true lovers' knots, on this wonderful piece of Renaissance woodwork, for in 1536, the date of the screen, Anne, charged with unfaithfulness, went to the scaffold. How was it, we wonder, that these initials were never removed?

The screen also reminds us of the changes in architecture and religion which had swept over England between the laying of the foundation stone and the completion of the internal fittings, for, not only had the Gothic order come to its greatest perfection in this building, and then its whole traditions been abandoned and a reversion to classic forms taken place, but the very religion for which the chapel had been built had been swept away by the Reformation.

The Tudor rose and portcullis frequently repeated within and without the chapel constantly remind us of the important part Henry VII. played in the creation of one of the chiefest flowers of the Gothic order and the architectural triumph of Cambridge.

TRINITY COLLEGE

Oxford does not possess so large a foundation as Trinity College, and the spaciousness of the great court impresses the stranger as something altogether exceptional in collegiate buildings, but, like the British Constitution, this largest of the colleges only assumed its present appearance after many changes, including the disruptive one brought about by Henry VIII. In that masterful manner of his the destroyer of monasticism, having determined to establish a new college in Cambridge, dissolved not only King's Hall and Michael House, two of the earliest foundations, but seven small university hostels as well. The two old colleges were obliged to surrender their

charters as well as their buildings; the lane separating them was closed, and then, with considerable revenues obtained from suppressed monasteries, Henry proceeded to found his great college dedicated to the Trinity.

There is something in the broad and spacious atmosphere of the Great Court suggestive of the change from the narrow and cramped thought of pre-Reformation times to the age when a healthy expansion of ideas was coming like a fresh breeze upon the mists which had obscured men's visions. But even as the Reformation did not at once sweep away all traces of monasticism, so Henry's new college retained for a considerable time certain of the buildings of the two old foundations which were afterwards demolished or rebuilt to fit in with the scheme of a great open court. Thus it was not until the mastership of Thomas Nevile that King Edward's gate tower was reconstructed in its present position west of the chapel. On this gate, beneath the somewhat disfiguring clock, is the statue of Edward III., regarded as a work of the period of Edward IV.

Shortly before Henry made such drastic changes, King's Hall had been enlarged and had built itself a fine gateway of red brick with stone dressings, and this was made the chief entrance to the college. The upper part and the statue of Henry VIII. on the outer face were added by Nevile between 1593 and 1615, but otherwise, the gateway is nearly a whole century earlier.

It is interesting to read the founder's words in regard to the aims of his new college, for in them

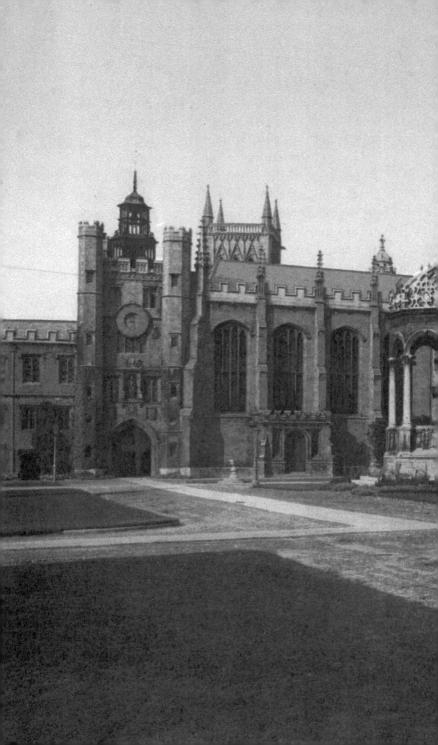

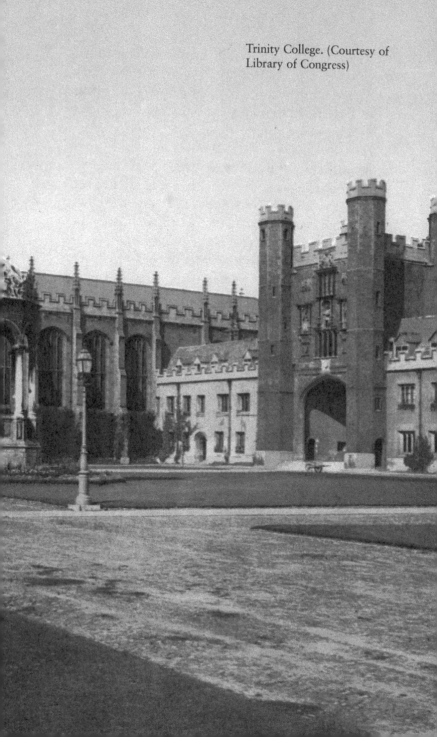

Trinity College. (Courtesy of Library of Congress)

we seem to feel his wish to establish an institution capable in some measure of filling the gap caused by the suppression of so many homes of learning in England. Trinity was to be established for 'the development and perpetuation of religion' and for 'the cultivation of wholesome study in all departments of learning, knowledge of languages, the education of youth in piety, virtue, self-restraint and knowledge; charity towards the poor, and relief of the afflicted and distressed.'

To the right on entering the great gateway is the chapel, a late Tudor building begun by Queen Mary and finished by her sister Elizabeth about the year 1567. The exterior is quite mediaeval, and all the internal woodwork, including the great baldachino of gilded oak, the stalls and the organ screen dividing the chapel into two, dates from the beginning of the eighteenth century. In the ante-chapel the memory of some of the college's most distinguished sons is perpetuated in white marble. Among them we see Macaulay and Newton, whose rooms were between the great gate and the chapel, Tennyson, Whewell–the master who built the courts bearing his name, was active in revising the college statutes, and died in 1866–Newton, Bacon, Wordsworth and others.

On the west side of the court, beginning at the northern end, we find ourselves in front of the Lodge, which is the residence of the Master of the College. The public are unable to see the fine interior with its beautiful dining- and drawing-rooms and the interesting collection of college portraits hanging there, but they

can see the famous oriel window built in 1843
with a contribution of £1,000 from Alexander
Beresford-Hope. This sum, however, even with
£250 from Whewell, who had just been elected
to the mastership, did not cover the cost, and
the fellows had to make up the deficit. It was
suggested that Whewell might have contributed
more had not his wife dissuaded him, and a
fellow wrote a parody of 'The House that Jack
Built' which culminated in this verse:

This is the architect who is rather a muff,
Who bamboozled those seniors that cut up so rough,
When they saw the inscription, or rather the puff,
Placed by the master so rude and so gruff,
Who married the maid so Tory and tough,
And lived in the house that Hope built.

The Latin inscription, omitting any reference to
the part the fellows took in building the oriel,
may still be read on the window.

In the centre of this side of the court is a
doorway approached by a flight of steps, and, from
the passage to which this leads, we enter the Hall.
It was built in the first decade of the seventeenth
century, and the screen over the entrance with the
musicians' gallery behind belongs to that period.

Unfortunately, the panelling along the sides has
replaced the old woodwork in recent times. This
beautiful refectory resembles in many ways the
Middle Temple Hall in London. The measurements
are similar, it has bay windows projecting at either
end of the high table, a minstrels' gallery at the

opposite end, and well into the last century was heated by a great charcoal brazier in the centre. The fumes found their way into every corner of the hall before reaching their outlet in the lantern. Among the numerous portraits on the walls there are several of famous men. Among them we find Dryden, Vaughan, Thompson (by Herkomer), the Duke of Gloucester (by Sir Joshua Reynolds), Coke (the great lawyer), Thackeray, Tennyson (by G.F. Watts), Cowley and Bentley. On the other side of the entrance passage are the kitchens with the combination rooms above, where more notable portraits hang. The remainder of the court is composed of living-rooms broken by the Queen's Gate, a fine tower built in 1597 facing King Edward's Gate. It has a statue of Elizabeth in a niche and the arms of Nevile and Archbishop Whitgift.

Nevile's Court is approached by the passage giving entrance to the hall. The eastern half was built when Nevile was master between 1593 and 1615, and the library designed by Sir Christopher Wren occupies the river frontage. To the casual observer this building is a comparatively commonplace one, built in two stories, but although it allows space for the arcaded cloister to go beneath it, the library above consists of one floor and the interior does not in the least follow the external lines. On great occasions Nevile's Court is turned into a most attractive semi-open-air ball or reception room. One memorable occasion was when the late King Edward, shortly after his marriage, was entertained with his

beautiful young bride at a ball given at his old college.

Passing out of the court to the lovely riverside lawns, shaded by tall elms and chestnuts, we experience the ever-fresh thrill of the Cambridge 'Backs,' and, crossing Trinity Bridge, walk down the stately avenue leading away from the river with glimpses of the colleges seen through the trees so full of suggestive beauty as to belong almost to a city of dreams. There are other courts belonging to Trinity, including two gloomy ones of recent times on the opposite side of Trinity Street, but there is, alas! no space left to tell of their many associations.

THE LESSER COLLEGES

PETERHOUSE

Taking the smaller colleges in the order of their founding, we come first of all to Peterhouse, already mentioned more than once in these pages on account of its antiquity, so that it is only necessary to recall the fact that Hugh de Balsham, Bishop of Ely, founded this the first regular college in 1284. Of the original buildings of the little hostel nothing remains, and the quadrangle was not commenced until 1424, but the tragedy which befell the college took place in the second half of the eighteenth century, when James Essex, who built the dreary west front of Emmanuel, was turned loose in the court. His hand was fortunately stayed before he had touched the garden side of the southern wing, and the picturesque range of fifteenth-century buildings, including the hall and combination room, remains one of the most pleasing survivals of mediaeval architecture in Cambridge.

Dr Andrew Perne, also known as 'Old Andrew Turncoat,' and other names revealing his willingness to fall in with the prevailing religious ideas of the hour, was made Master of Peterhouse in 1554, and subsequently he became Vice-Chancellor of the University. He added to the library the extension which now overlooks Trumpington Street, and to him the town is largely indebted for those little runnels of sparkling water to be seen flowing along by the curbstones of some of the streets. The chapel was added in 1632 by Bishop Matthew Wren in the Italian Gothic style then prevalent, and its dark panelled interior is chiefly noted for its Flemish east window. The glass was taken out and hidden in the Commonwealth period, and replaced when the wave of Puritanism had spent itself. All the other windows are later work by Professor Aimmuller of Munich. Before this chapel was built the little parish church of St Peter, which stood on the site of the present St Mary the Less, supplied the students with all they needed in this direction.

CLARE

Michael House, the second college, was, as we have seen, swept away to make room for Trinity, so that the second in order of antiquity is Clare College, whose classic facade of great regularity, with the graceful little stone bridge spanning the river, is one of the most familiar features of

the 'Backs.' The actual date of the founding of the college by Elizabeth de Burgh, daughter of Gilbert de Clare, was 1342, and the court, then built in the prevalent Decorated style, continued in use until 1525, when it was so badly damaged by fire that a new building was decided upon, but the work was postponed until 1635, and was only finished in the second year of the Restoration. Although no shred of evidence exists as to the architect, tradition points to Inigo Jones, whose death took place, however, in 1652. The bridge is coeval with the earliest side of the court, having been finished in 1640. In the hall, marred by great sheets of plate-glass in the windows, there are portraits of Hugh Latimer, Thomas Cecil (Earl of Exeter), Elizabeth de Clare (foundress), and other notable men.

PEMBROKE

Like Clare, Pembroke College was founded by a woman. She was Marie de St Paul, daughter of Guy de Chatillon, and on her mother's side was a great-granddaughter of Henry III. She was also the widow of Aymer de Valance, Earl of Pembroke, whose splendid tomb is a conspicuous feature of the Sanctuary in Westminster Abbey.

Instead of the usual modest beginning with one or two existing hostels adapted for the purposes of a purely academic society, the foundress cleared away the hostels on the site nearly opposite historic Peterhouse, and began a regular quadrangle, the

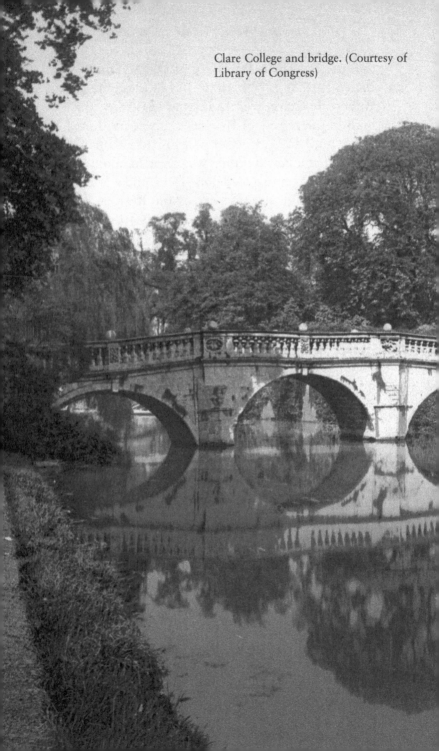

Clare College and bridge. (Courtesy of Library of Congress)

first of the non-religious type Cambridge had known. An existing hostel formed one side, but the others were all erected for the special purpose of the college. A hall and kitchen were built to the east, and on the street side opposite was a gateway placed between students' rooms. Marie de St Paul also received permission from two successive Avignonese Popes to build a chapel with a bell tower at the north-west corner of the quadrangle, and to some extent these exist to-day, incorporated in the reference library and an adjoining lecture-room. Of the other buildings to be seen at the present time the oldest is the Ivy Court, dating from 1633 to 1659. Since then architect has succeeded architect, from Sir Christopher Wren, who built a new chapel in 1667, to Mr G.G. Scott, the designer of the most easterly buildings in the style of the French Renaissance. Between these comes the street front by Waterhouse, for whose unpleasing facade no one seems to have a good word. There has indeed been such frequent rebuilding at Pembroke that the glamour of association has been to a great extent swept away. This is doubly sad in view of the long list of distinguished names associated with the foundation. Among them are found Thomas Rotherham, Archbishop of York, who was Master of Pembroke; Foxe, the great Bishop of Winchester and patron of learning; Ridley; Grindal, afterwards Archbishop of Canterbury; Matthew Hutton and Whitgift. Beside these masters Edmund Spenser, the poet Gray, and William Pitt are names of which Pembroke will always be proud.

CAIUS

In the year following the founding of Pembroke Edmund de Gonville added another society to those already established. This was in 1348, but three years later the good man died and left the carrying on of his college to William Bateman, Bishop of Norwich, who had just founded Trinity Hall. He found it convenient to transfer Gonville's foundation to a site opposite his own college, and from this time until the famous Dr Caius (Kayes or Keyes) reformed it in 1557, the college was known as Gonville Hall.

The buildings now comprise three courts, the largest called Tree Court, being to the east, and the two smaller called Gonville and Caius respectively, to the west side, separated from Trinity Hall by a narrow lane. Tree Court had been partly built in Jacobean times by Dr Perse, whose monument can be seen in the chapel; but in 1867 Mr Waterhouse was given the task of rebuilding the greater part of the quadrangle. He decided on the style of the French Renaissance, and struck the most stridently discordant note in the whole of the architecture of the colleges. The tall-turreted frontage suggests nothing so much as the municipal offices of a flourishing borough. The present hall, built by Salvin in 1854, was decorated and repanelled by Edward Warren in 1909. Two of the three curiously named gateways built by Dr Caius still survive, and one of them, the Gate of Honour, opening on to Senate House Passage, is one of the most delightful things in Cambridge. Dr Caius had been a Fellow of Gonville Hall, and,

Caius College. (Courtesy of
Library of Congress)

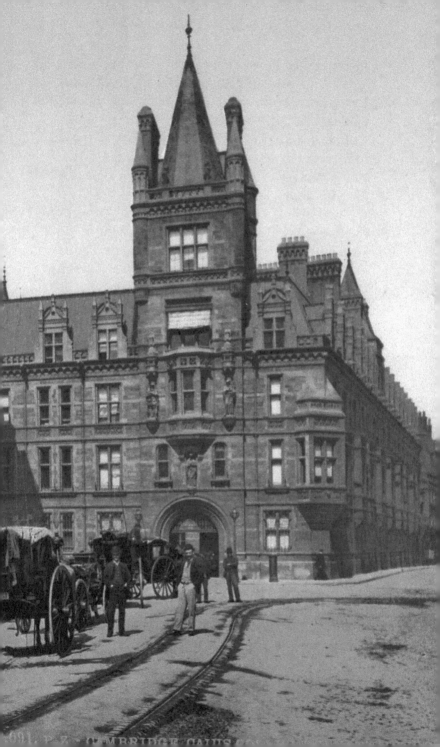

having taken up medicine, continued his studies at the University of Padua; and after considerable European travel practised in England with such success that he was appointed Physician to the Court of Edward VI. Philip and Mary showed him great favour, and his reputation grew owing to his success in treating the sweating sickness. Having acquired much wealth, he decided to refound his old college, and the Italian Gothic of the two gateways is evidence of his delight in the style with which he had become familiar at Padua and elsewhere. He built the two wings of the Caius Court, leaving the Court open towards the south. The idea of his three gates, beginning with the simple Gate of Humility, leading to the Gate of Virtue, and so to that of Honour, is very fitting, for such sermons in stones could scarcely find a better place than in a university. Caius has many famous medical men, treasuring the memory of Harvey, who discovered the circulation of the blood, and of Dr Butts, who was Henry VIII.'s physician.

TRINITY HALL

As already mentioned, Trinity Hall was founded two years after Gonville made his modest foundation. It is specialized in relation to law as its neighbour is to medicine. Although architecturally of less account, its modern work is free from anything obtrusively out of keeping with academic tradition. Salvin's uninspired

eastern side of the court containing the entrance was built after a fire in 1852, and is typical of his harsh and unsympathetic work. Behind the Georgian front of the north side of this court, there is a good deal of the fabric of the Tudor buildings, and some of the lecture-rooms, with their oak panelling and big chimneys, are most picturesque.

On the west side is the hall, dating from 1743, and the modern combination room, containing a curious old semi-circular table, with a counter-balance railway for passing the wine from one corner to the other. The chapel is on the south side, and is a few years earlier than the hall.

CORPUS CHRISTI

Within two years from the founding of Trinity Hall Corpus Christi came into being, the gild of St Benedict's Church, in conjunction with that of St Mary the Great, having obtained a charter for this purpose from Edward III. in 1352, Henry Duke of Lancaster, the King's cousin, being alderman at that time.

This was the last of the colleges founded in the first period of college-building, and it has managed to preserve under the shadow of the Saxon tower of the parish church, which was for long the college chapel, one of the oldest and most attractive courts in Cambridge. Several of the windows and doors have been altered in later times, but otherwise three sides of the court are completely mediaeval. Having

Corpus Christi. (Courtesy of Library of Congress)

retained this fine relic, the college seems to have been content to let all the rest go, when, in 1823, Wilkins, whose bad Gothic we have seen at King's College, was allowed to rebuild the great court, including the chapel and hall. Sir Nicholas Bacon and Matthew Parker, Archbishop of Canterbury, are two of the most famous names associated with Corpus Christi. Parker left his old college a splendid collection of manuscripts, which are preserved in the library. This college has a strong ecclesiastical flavour, and it is therefore fitting that it should possess such a remarkable document as the original draft of the Thirty-nine Articles, which is among the treasured manuscripts.

QUEENS

After the founding of Corpus there came an interval of nearly a century before the eight colleges then existing were added to. Henry VI. founded King's in 1441, and seven years later his young Queen Margaret of Anjou, who was only eighteen, was induced by Andrew Docket to take over his very modest beginning in the way of a college. It was refounded under the name of Queen's College, having in the two previous years of its existence been dedicated to St Bernard. As in the case of King's, the progress of Margaret's college was handicapped by the Wars of the Roses, but fortunately Edward IV.'s Queen, Elizabeth Woodville, espoused the cause of Margaret's college when Docket appealed to her for help.

Above all other memories this college glories in its associations with Erasmus, who was probably advised to go there by Bishop Fisher. There are certain of his letters extant which he dates from Queens', and it is interesting to find that he wrote in a querulous fashion of the bad wine and beer he had to drink when his friend Ammonius failed to send him his usual cask of the best Greek wine. He also complained of being beset by thieves, and being shut up because of plague, but it need not be thought from this that Cambridge was much worse than other places.

Of all the colleges in the University Queens' belongs most completely to other days. Its picturesque red brick entrance tower is the best of this type of gateway, which is such a distinctive feature of Cambridge, and the first court is similar to St John's, with which Bishop Fisher was so closely connected as Lady Margaret Beaufort's executor. In the inner court, whose west front makes a charming picture from the river, is the President's Lodge occupying the north side. Its oriel windows and rough cast walls of quite jovial contours overhanging the dark cloisters beneath strike a different note to anything else in Cambridge. Restoration has altered the appearance of the hall since its early days, but it is an interesting building, with some notable portraits and good stained glass. The court, named after Erasmus, at the south-west angle of the college was, it is much to be regretted, rebuilt by Essex in the latter part of the eighteenth century; but for this the view of the river front from the

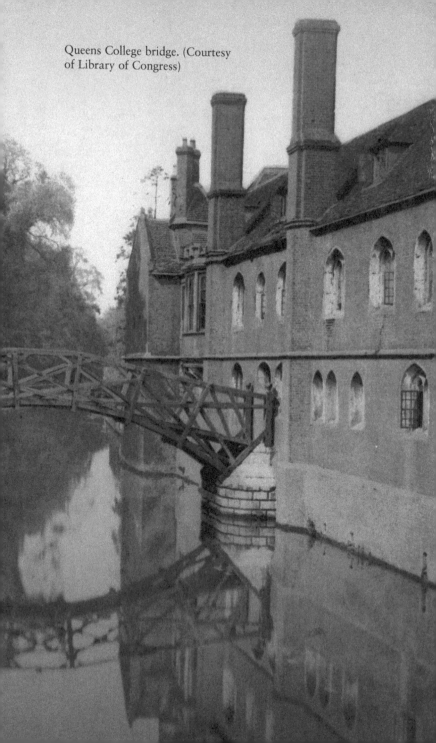

Queens College bridge. (Courtesy of Library of Congress)

Queens College.
(Courtesy of Library of
Congress)

curiously constructed footbridge would have been far finer than it is. Like the sundial in the first court, this bridge, leading to soft meadows beneath the shade of great trees, is attributed to Sir Isaac Newton.

ST CATHERINES

This college was founded in 1473 by Robert Woodlark, Chancellor of the University, and dedicated to 'the glorious Virgin Martyr, St Catherine of Alexandria.' Undergraduate slang, alas! reduces all this to 'Cat's.' It was originally called St Catherine's Hall, and is one of the smallest of the colleges. Although not claiming the strong ecclesiastical flavour of Corpus, it has educated quite a formidable array of bishops. From Trumpington Street the buildings have the appearance of a pleasant manor-house of Queen Anne or early Georgian days, and, with the exception of the wing at the north-west, the whole of the three-sided court dates between 1680 and 1755. Both chapel and hall are included in this period.

JESUS

Standing so completely apart from the closely clustered nucleus, Jesus College might be regarded as a modern foundation ranking with Downing or Selwyn by the hurried visitor who had failed

to consult his guide-book and had not previous information to aid him. It was actually founded as long ago as 1497, and the buildings include the church and other parts of the Benedictine nunnery of the Virgin and St Rhadegund.

Bishop Alcock, of Ely, was the founder of the college, and his badge, composed of three cocks' heads, is frequently displayed on the buildings. The entrance gate, dating from the end of the fifteenth century, with stepped parapets, is the work of the founder, and is one of the best features of the college. Passing through this Tudor arch, we enter the outer court, dating from the reign of Charles I., but finished in Georgian times. From this the inner court is entered, and here we are in the nuns' cloister, with their church, now the college chapel, to the south, and three beautiful Early English arches, which probably formed the entrance to the chapter-house, noticeable on the east. In this court are the hall, the lodge, and the library, but the most interesting of all the buildings is the chapel. It is mainly the Early English church of the nunnery curtailed and altered by Bishop Alcock, who put in Perpendicular windows and removed aides without a thought of the denunciations he has since incurred. In many of the windows the glass is by Morris and Burne-Jones, and the light that passes through them gives a rich and solemn dignity to the interior.

CHRISTS

Perhaps the most impressive feature of Christ's College is the entrance gate facing the busy shopping street called Petty Cury. The imposing

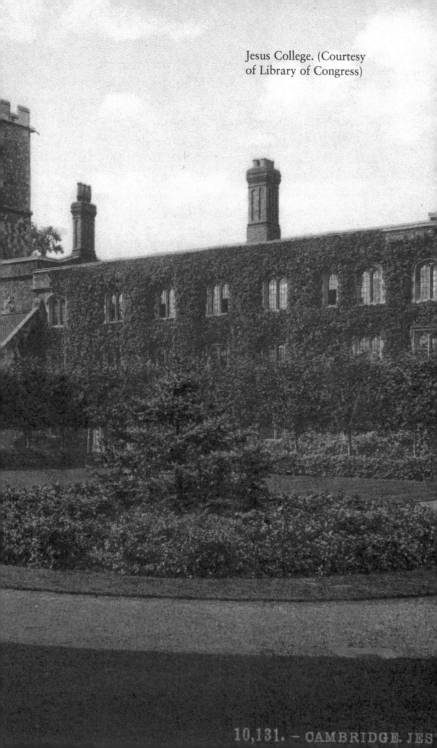

Jesus College. (Courtesy of Library of Congress)

10,131. – CAMBRIDGE. JES

heraldic display reminds us at once of Lady Margaret Beaufort, who, in 1505, refounded God's House, the hostel which had previously stood here. Although restored, the chapel is practically of the same period as the gateway, and it and the hall have both interesting interiors. From the court beyond, overlooked on one side by the fine classic building of 1642 attributed to Inigo Jones, entrance is gained to the beautiful fellows' garden, where the mulberry-tree associated with the memory of Milton may still be seen.

MAGDALENE

This college is the only old one on the outer side of the river. It stands on the more historic part of Cambridge; but although an abbey hostel was here in Henry VI.'s time, it was not until 1542, after the suppression of Crowland Abbey, to which the property belonged, that Magdalene was founded by Thomas, Baron Audley of Walden. In the first court of ivy-grown red brick is the rather uninteresting chapel, and on the side facing the entrance the hall stands between the two courts. It has some interesting portraits, including one of Samuel Pepys, and a good double staircase leading to the combination room, but more notable than anything else is the beautiful Renaissance building in the inner court, wherein is preserved the library of books Pepys presented to his old college. In the actual glass-covered bookcases in which he kept them, and in the very order, according to

size, that Pepys himself adopted, we may see the very interesting collection of books he acquired. Here, too, is the famous Diary, in folio volumes, of neatly written shorthand, and other intensely interesting possessions of the immortal diarist.

EMMANUEL

The college stands on the site of a Dominican friary, but Sir Walter Mildmay, the founder, or his executors, being imbued with strong Puritanism, delighted in sweeping away the monastic buildings they found still standing. Ralph Symons was the first architect, but all his excellent Elizabethan work has vanished, the oldest portion of the college only dating back to 1633. From that time up to the end of the eighteenth century the rest of the structures were reconstructed in the successive styles of classic revival. Wren began the work, but unluckily it was left to Essex to complete it, and he is responsible for the dreary hall occupying the site of the old chapel.

SIDNEY SUSSEX

At the foot of the list of post-Reformation colleges comes Sidney Sussex, founded, in 1589, by Frances Lady Sussex, daughter of Sir William Sidney, and widow of the second Earl of Sussex. During the mania for rebuilding, all the Elizabethan work of Ralph Symons was replaced by Essex, and in

the nineteenth century the notorious Wyatville, whose Georgian Gothic removed all the glamour from Windsor Castle, finished the work.

DOWNING

The remaining colleges belong to the period we may call recent. Downing, the first of these, was not a going concern until 1821, although Sir George Downing, the founder, made the will by which his property was eventually devoted to this purpose as early as the year 1717.

RIDLEY HALL

This came into being in 1879, and is an adjunct to the other colleges for those who have already graduated and have decided to enter the Church.

SELWYN COLLEGE

Founded about the same time, this is named after the great Bishop Selwyn, who died in 1877. The college aims at the provision, on a hostel basis, of a University education on a less expensive scale than the older colleges.

Of the two women's colleges, Girton was founded first. This was in 1869, and the site chosen was as far away as Hitchen, but four years later, gaining confidence, the college was

moved to Girton, a mile north-west of the town, on the Roman Via Devana. Newnham arrived on the scene soon afterwards, and, considering proximity to the University town no disadvantage, the second women's college was planted between Ridley and Selwyn, with Miss Clough as the first principal.

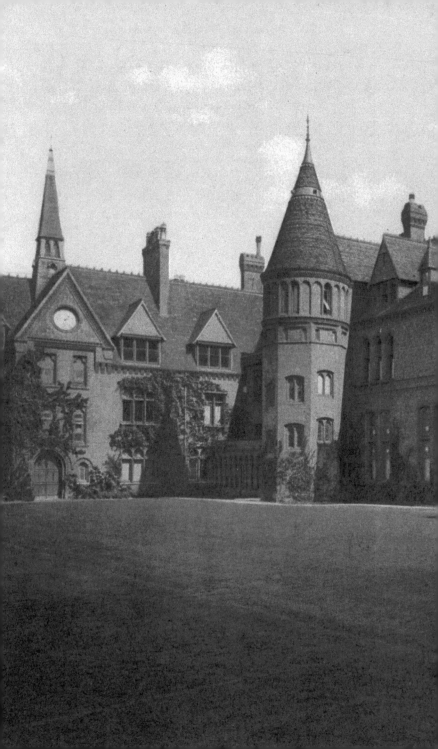

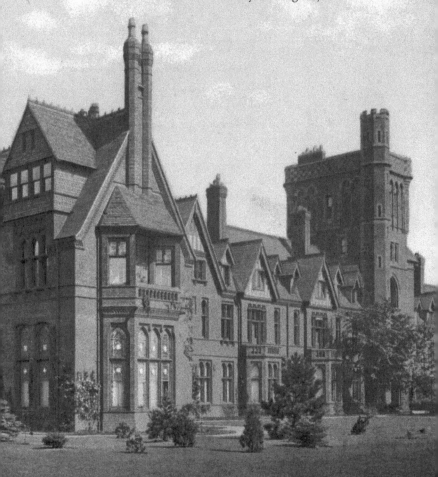

Girton College. (Courtesy of Library of Congress)

THE UNIVERSITY LIBRARY, THE SENATE HOUSE, THE PITT PRESS, AND THE MUSEUMS

In the early days when the University of Cambridge was still in an embryonic state, the various newly formed communities of academic learning had no corporate centre whatever. 'The chancellor and masters' are first mentioned in a rescript of Bishop Balsham dated 1276, eight years before he founded Peterhouse, the first college, and six years before this Henry III. had addressed a letter to 'the masters and scholars of Cambridge University,' so that between these two dates it would appear that the chancellor really became the prime academic functionary. But it was not until well into the fourteenth century that any University buildings made their appearance.

The 'schools quadrangle' was begun when Robert Thorpe, knight, was chancellor (1347-

64), and during the following century various schools for lecturing and discussions on learned matters were built round the court, now entirely devoted to the library. Unfortunately, the medieval character of these buildings has been masked by a classic facade on the south, built in 1754, when it was thought necessary to make the library similar in style to the newly built Senate House. Thus without any further excuse the fine Perpendicular frontage by Thomas Rotherham, Bishop of Lincoln and fellow of King's, was demolished to make way for what can only be called a most unhappy substitute. George I. was really the cause of this change, for in 1715 he presented Cambridge with Dr John Moore's extensive library, and not having the space to accommodate the little Hanoverian's gift, the authorities decided to add the old Senate House, which occupied the north side of the quadrangle, to the library, and to build a new Senate House; and the building then erected, designed by Mr., afterwards Sir James, Burrough, is still in use. It is a well-proportioned and reposeful piece of work, although the average undergraduate probably has mixed feelings when he gazes at the double line of big windows between composite pillasters supporting the rather severe cornice. For in this building, in addition to the 'congregations,' or meetings, of the Senate consisting of resident and certain non-resident masters of art, the examinations for degrees were formerly held. Here on the appointed days, early in the year, the much-crammed undergraduates passed six hours

of feverish writing, and here, ten days later, in the midst of a scene of long-established disorder, their friends heard the results announced. Immediately the name of the Senior Wrangler was given out there was a pandemonium of cheering, shouting, yelling, and cap-throwing, and the same sort of thing was repeated until the list of wranglers was finished. Following this, proctors threw down from the oaken galleries printed lists of the other results, and a wild struggle at once took place in which caps and gowns were severely handled, and for a time the marble floor was covered with a fighting mob of students all clutching at the fluttering papers, while the marble features of the two first Georges, William Pitt, and the third Duke of Somerset remained placidly indifferent.

Although there is no space here to describe the many early books the library contains, it is impossible to omit to mention that among the notable manuscripts exhibited in the galleries is the famous Codex Bezae presented to the University by Theodore Beza, who rescued it, in 1562, when the monastery at Lyons, in which it was preserved, was being destroyed. This manuscript is in uncial letters on vellum in Greek and Latin, and includes the four Gospels and the Acts.

It was a pardonable mistake for the old-time 'freshman' to think the Pitt Press in Trumpington Street was a church, but no one does this now, because the gate tower, built about 1832, when the Gothic revival was sweeping the country, is now known as 'the Freshman's Church.' The Pitt

Press was established with a part of the fund raised to commemorate William Pitt, who was educated at Pembroke College nearly opposite.

The University Press publishes many books, and gives special attention to books the publication of which tends to the advancement of learning. The two Universities and the King's printer have still a monopoly in printing the Bible and Book of Common Prayer. The magnificent museum founded by Richard, Viscount Fitzwilliam, is a little farther down Trumpington Street. It was finished in 1847 by Cockerell, who added the unhappy north side to the University Library, but the original architect was Basevi, who was prevented from finishing the building he had begun by his untimely death through falling from one of the towers of Ely Cathedral. The magnificence of the great portico, with its ceiling of encrusted ornament, is vastly impressive, but the marble staircase in the entrance lobby, with its rich crimson reds, is rather overpowering in conjunction with the archaeological exhibits. Plainer, cooler and less aggressive marble such as that employed in the lobby of the Victoria and Albert Museum would have been more suitable. A very considerable proportion of the museum's space is devoted to the collection of pictures–some of them copies–which the University has gathered. The interesting Turner water-colours presented by John Ruskin are here, with a Murillo, reputed to be his earliest known work, and a good many other examples of the work of famous men of the Italian and Dutch Schools.

Besides the Museum of Archaeology, between Peterhouse and the river, the vigorous growth of

the scientific side of the University is shown in the vast buildings newly erected on both sides of Downing Street, which has now become a street of laboratories and museums. Now that the outworks of the hoary citadel of Classicism have been stormed, and the undermining of the great walls has already begun, the development of modern science at Cambridge will be accelerated, and in the face of the urgency of the demands of worldwide competition it would appear that the University on the Cam is more fitted to survive than her sister on the Isis.

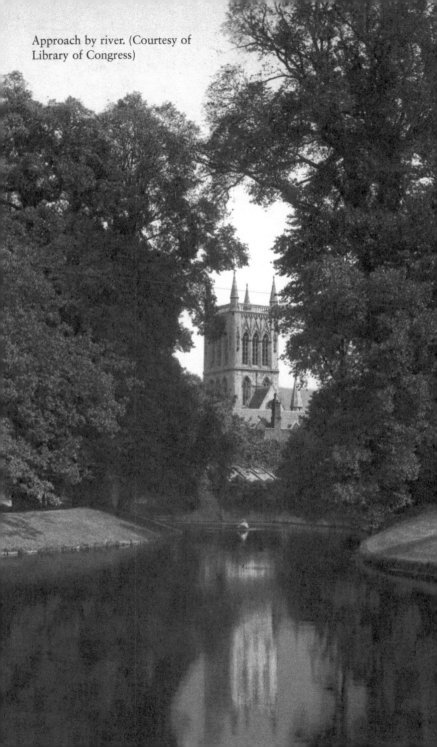

Approach by river. (Courtesy of Library of Congress)

THE CHURCHES
IN THE TOWN

Almost everyone who goes to Cambridge as a visitor bent on sightseeing naturally wishes to see the colleges before anything else, but it should not be forgotten that there are at least two churches, apart from the college chapels, whose importance is so great that to fail to see them would be a criminal omission. There are other churches of considerable interest, but for a description of them it is unfortunately impossible to find space.

Foremost in point of antiquity comes St Benedict's, or St Benet's, possessing a tower belonging to pre-Conquest times, and the only structural relic of the Saxon town now in existence. The church was for a considerable time the chapel of Corpus Christi, and the ancient tower still rises picturesquely over the roofs of the old court of that college.

Without the tower, the church would be of small interest, for the nave and chancel are comparatively late, and have been rather drastically restored. The interior, nevertheless, is quite remarkable in possessing a massive Romanesque arch opening into the tower, with roughly carved capitals to its tall responds. Outside there are all the unmistakable features of Saxon work–the ponderously thick walls, becoming thinner in the upper parts, the 'long and short' method of arranging the coigning, and the double windows divided with a heavy baluster as at Wharram-le-Street in Yorkshire, Earl's Barton in Northamptonshire, and elsewhere.

Next in age and importance to St Benedict's comes what is popularly called 'the Round Church,' one of the four churches of the Order of Knights Templar now standing in this country. The other three are the Temple Church in London, St Sepulchre's at Northampton, and Little Maplestead Church in Essex, and they are given in chronological order, Cambridge possessing the oldest. It was consecrated the Church of the Holy Sepulchre, and was built before the close of the eleventh century, and is therefore a work of quite early Norman times. The interior is wonderfully impressive, for it has nothing of the lightness and grace of the Transitional work in the Temple, and the heavy round arches opening into the circular aisle are supported by eight massive piers. Above there is another series of eight pillars, very squat, and of about the same girth as those below, and the spaces between are subdivided by a small

pillar supporting two semi-circular arches. Part of the surrounding aisle collapsed in 1841, and the Cambridge Camden Society (now defunct) employed the architect Salvin to thoroughly restore the church. He took down a sort of battlemented superstructure erected long after the Norman period, and built the present conical roof.

After these early churches, the next in interest is Great St Mary's, the University Church, conspicuously placed in the market-place and in the very centre of the town. It has not, however, always stood forth in such distinguished isolation, for only as recently as the middle of last century did the demolition take place of the domestic houses that surrounded it. And inside, the alterations in recent times have been quite as drastic, robbing the church of all the curious and remarkable characteristics it boasted until well past the middle of the nineteenth century, and reducing the whole interior to the stereotyped features of an average parish church.

If we enter the building to-day without any knowledge of its past, we merely note a spacious late Perpendicular nave, having galleries in the aisles with fine dark eighteenth-century panelled fronts, and more woodwork of this plain and solemn character in front of the organ, in the aisle chapels, and elsewhere. A soft greenish light from the clerestory windows (by Powell), with their rows of painted saints, falls upon the stonework of the arcades and the wealth of dark oak, but nothing strikes us as unusual until we discover

that the pulpit is on rails, making it possible to draw it from the north side to a central position beneath the chancel arch. This concession to tradition is explained when we discover the state of the church before 1863, when Dr Luard, who was then vicar, raised an agitation, before which the Georgian glories of the University Church passed away. Before the time of Laud, when so many departures from mediaeval custom had taken place, we learn, from information furnished during the revival brought about by the over-zealous archbishop, that the church was arranged much on the lines of a theatre, with a pulpit in the centre, which went by the name of the Cockpit, that the service was cut as short as 'him that is sent thither to read it' thought fit, and that during sermon-time the chancel was filled with boys and townsmen 'all in a rude heap between the doctors and the altar.' But this concentration on the University sermon and disrespect for the altar went further, for, with the legacy of Mr William Worts, the existing galleries were put up in 1735, the Cockpit was altered, and other changes made which Mr A.H. Thompson has vividly described:

The centre of the church was filled with an immense octagonal pulpit on the 'three-decker' principle, the crowning glory and apex of which was approached, like a church-tower, by an internal staircase. About 1740 Burrough filled the chancel-arch and chancel with a permanent gallery, which commanded a thorough view of this object. The gallery, known as the 'Throne,' was an extraordinary and unique erection. The

royal family of Versailles never worshipped more comfortably than did the Vice-Chancellor and heads of houses, in their beautiful armchairs, and the doctors sitting on the tiers of seats behind them. In this worship of the pulpit, the altar was quite disregarded.... The church thus became an oblong box, with the organ at the end, the Throne at the other, and the pulpit between them. Of all this nothing remains besides the organ and the side galleries, and of the splendid screen, built in 1640 to replace its still finer predecessor, swept away by Archbishop Parker nearly a century before, only that portion running across the north chapel remains.

Until the Senate House was built, the commencements were held in the church, but thereafter it would appear that the sermon flourished almost to the exclusion of anything else.

The diminutive little church of St Peter near the Castle mound is of Transitional Norman date, and has Roman bricks built into its walls.

O fairest of all fair places,
Sweetest of all sweet towns!
With the birds and the greyness and greenness,
And the men in caps and gowns.
All they that dwell within thee,
To leave are ever loth,
For one man gets friends, and another
Gets honour, and one gets both.

A rowing scene. (Courtesy of Library of Congress)

SOCIAL LIFE AT CAMBRIDGE

In our previous articles we have given a series of historical notes concerning the most important colleges. These have related chiefly to the buildings. We now propose to say something more about the social makeup of the town and University; for just as the records of a nation are incomplete when they treat only of public affairs, so any account of Cambridge would be imperfect if the writer did not try to describe some at least of the changes that have taken place, from time to time, in the habits, the tastes, and the pursuits of the academic body. The Universities must always reflect the tastes and opinions of the country, and therefore we find that these changes have been more rapid and more thorough during the last half-century than during any previous period. On this account we shall not attempt to go back to any very distant date in our researches, though occasionally it will be necessary to mention the habits of the sixteenth and seventeenth centuries

by way of illustration. It will be sufficient for our purpose to sketch that Cambridge which came to an end with the introduction of railroads, gas, and other innovations peculiar to this century; and, in order roughly to indicate the period from which we start, we have ventured to borrow a title from the author of Waverley.

To begin with, it must be borne in mind that the town of Cambridge was very different then from what it is now; indeed, with the exception of the destruction of the great religious houses, it had not been much altered during the four centuries since the period at which we attempted to sketch its aspect in our first chapter. The country round about it was quite unenclosed, and to the south and south-east a man on horseback might gallop for miles, uninterrupted by a single fence. The ground where the now populous 'New Town' stands was then a swamp, where sportsmen were sure of snipe, and the road that now leads to the railway station was an elevated cause;way, with this marshy ground to the right of it. The velvety turf of Gogmagog Hills had not then been ploughed up, and a bustard was still occasionally to be seen there. The streets could hardly have been worse paved than they are at present, but some of them were much narrower. A row of ancient houses stood where the lawn in front of King's College now is, at a distance varying from ten to twenty feet in advance of the present iron fence. Trumpington Street, in this part of its course, was nowhere more than twenty-five feet wide, and as the upper storeys of

the houses projected beyond those beneath them, it used to be maintained, graphically rather than delicately, that a man could spit across it. The only light used at night in the streets was oil. Only one post came in and one went out in the twenty-four hours. There were no public conveyances. If a gentleman did not keep his own carriage, he must walk. Ladies went out at night in sedan chairs. At the end of the previous century there had been only one umbrella, according to Professor Pryme; and this was kept at a shop in Bene't Street, and let out by the hour.

Passenger traffic was by coaches, which were numerous and well appointed, but slow; goods traffic by waggons, or by barges on the Cam, which was still, as in the Middle Ages, an important highway, along which all the fuel – coals, sedge, and turf – as well as a considerable quantity of provisions, was brought to the town. A long frost, therefore, meant death by cold, aggravated by hunger; and instances are on record of the burning of every article of furniture that could be dispensed with. The shops were exceedingly primitive. Most of them were open, like stalls, and closed at night with a single wide shutter that let down, and was used to display the goods on during the day. The principal purchases of stores of all kinds were made at the two great annual fairs, Midsummer Fair and Sturbridge Fair. The latter was by far the more important of the two, and until the introduction of railways must have been the chief event of the year, not only in Cambridge, but on the whole eastern side of England. The temporary

buildings required for it were commenced, by custom, on the 24th of August in each year, and the fair itself was solemnly proclaimed by the University on the 17th of September. The Vice-Chancellor, attended by the Bedells, Registrary, Proctors, and other officers, proceeded to the Senate House at eleven o'clock in the forenoon, where the Senior Proctor provided mulled wine, sherry, and cakes. These delicacies disposed of, the company proceeded in carriages to the fair, where the formal proclamation was read by the Registrary in three different places. The company then alighted at one of the permanent structures, called 'The Tiled Booth,' where they elbowed their way through a crowd of the ordinary customers of the house to an upstairs room, called 'The University Dining Room.' There they partook of oysters, ale, and porter. Thus fortified they walked in one of the streets of the Fair, called 'Garlick Fair Row,' until it was time to return to 'The Tiled Booth' for dinner. The University was very unpopular at the Fair, and it seems to have been usual to hustle the magnates, and to make their progress to their dinner as difficult as possible. Mr Gunning, Esquire Bedell from 1789 to 1854, describes this curious entertainment, which was not abolished until 1842, while the proclamation by the University survived until the Award Act of 1856:

'The scene which presented itself on entering the dining-room I can describe most accurately, for the dishes and their arrangement never varied. Before the

Vice-Chancellor was placed a large dish of herrings; then followed in order a neck of pork roasted, an enormous plum-pudding, a leg of pork boiled, a pease-pudding, a goose, a huge apple-pie and a round of beef in the centre. On the other half of the table the same dishes were placed in similar order, the herrings before the Senior Proctor, who sat at the bottom. From thirty to forty persons dined there; and although the wine was execrable, a number of toasts were given, and mirth and good humour prevailed to such an extent as is seldom to be met with at more modern and more refined entertainments. At about half-past six the dinner party broke up, and, with scarcely an exception, adjourned to the theatre.'

In the palmy days of the Fair the space occupied by it was about half a mile square, divided into streets, which were distinguished by separate names, such as 'Booksellers' Row,' 'Cooks' Row,' 'Cheapside,' 'The Duddery,' 'Garlick Fair Row,' etc. In each of these some special trade was represented, as in Leipsic Fair at the present day. The amount of business done was enormous. In 'The Duddery,' where woollen stuffs were sold, £100,000 worth of goods is reported to have been sold in less than a week, besides the quantity ordered by London traders, while elsewhere wool to the value of £50,000 or £60,000 was disposed of, and hops to an equal amount. The Horse Fair, held on September 14th, was always the most crowded day; but the numbers that assembled during the whole three weeks that the Fair lasted were very great. Notwithstanding the vast

concourse of people, the Fair is described to have been like 'a well-governed city,' where order was carefully and successfully preserved. There was a Court of Justice, of the kind called 'Pie Powder Court' elsewhere, where the Mayor of Cambridge, or his deputy, sat daily. On Sundays Divine service was held in the principal open space, and a sermon preached from a pulpit placed in the open air, by the minister of Barnwell parish, or by some one appointed by him. In addition to serious business there was, of course, plenty of amusement. It was a time of licensed frolic, into which all classes entered with equal zest and gaiety. The dramatic entertainments were managed by the company of the Norwich Theatre, one of the best provincial houses, and were well attended; while the wives of county magnates, of University dignitaries, and even of Heads of Houses, danced at the ball which was given on some particular evening in one of the booths. In the case of Midsummer Fair, when the days were longer, ladies used to get up tea-parties with the view of walking in the Fair afterwards.

The popularity of the theatre at the Fair was evidently very great in the last century, especially with members of the University. When Mr Gunning was a candidate for the office of Esquire Bedell, in September 1789, he mentions that after a morning spent in canvassing, he never failed to go to the theatre in the evening, feeling sure that if an elector had arrived at Cambridge in the course of the day, he should meet him there. In 1808, when Professor Sedgwick was reading

with pupils at Ditton, a village on the Cam, not far below Barnwell, his chief amusements seem to have been the theatre; and his letters tell us that he constantly met his friends there. In later times, when a permanent building had replaced the temporary structure at the Fair, it maintained its popularity until railways enabled everybody to get to London.

Most of the celebrated actors of the present century have acted on that miniature stage; and the last three weeks of the Long Vacation were looked forward to with eagerness by the play-loving portion of the community. So late as 1834, Mrs Frere, wife of the Master of Downing, bespoke the performance, and one of her party has recorded in his diary that the pieces selected were well acted. Thirty years ago, when I was an undergraduate, the theatre used to open as usual, but the audience was, to say the least of it, thin. Some of us went regularly, but the pieces performed usually belonged to what is so oddly called the legitimate drama, and I am afraid that we received Ingomar, Pizari-o, Hamlet, and The Stranger, with derisive merriment.

In early times undergraduates lived three and four together in a room; and even Fellows could not always have a room to themselves. The arrangements for this system differed in different colleges, and it would be beside our present purpose to go into the matter minutely. A certain amount of privacy was ensured by the contrivance of small studies (muscea), separated off by a lath-and-plaster partition from the rest

of the room. The beds were in the undivided portion, and the inmates retired into these closets for work. As colleges increased their buildings, the system was gradually given up, but it was still in fashion at St John's so late as 1711, as is seen by the following letter, which puts the advantages and disadvantages of it very forcibly. The writer is the father of Ambrose Bonwicke, who had entered there as pensioner in the autumn of the previous year. Ambrose had written to say that he had arranged for his brother Philip to share his room with him, and wished for leave to introduce a friend also:

'I thank you and your tutor for the promise of the chamber for Phil, and think there may be some conveniencies in admitting a third, but there may also be some inconveniencies which I shall lay before you. By the grace of God this lad may continue very good, and your society may contribute towards it; but should it be othermse, you will not know how to get clear of him again. Besides if he be not exactly of your principles, tho' he be otherwise very good, 'twill be very inconvenient; and you cannot at all times converse so freely with your brother, as 'twill be necessary you should. I had hopes that your brother might share with you in Mr Roper's favour, and fear this third chum may be an obstacle to that. Another thing is, if Phil. should have the small-pox, there will be no room for you to set up a bed for that time; and you κυοΑν I do not care you should lye with any other but your brother. If this lad has never had that distemper, he may unhappily bring the infection into

your chamber. Besides, I should not like him for a chvim for you, if his dialect be ungenteel, for fear that infection should reach you, as well as your brother. Yet after all, I have a great concern for so hopeful a lad as you describe him, and wish you might enjoy each other's society in the daytime, tho' you sleep not together; neither am I against that, if you can make me easy as to the foregoing particulars.'

By the end of the century, however, the present plan of living in lodgings in the town had been accepted, though not without many misgivings and attempts to stop it, or to limit it; attempts which have been renewed in our own time. Let us hope that the system, which is not a good one, may one day be superseded. In the days when rooms were shared, the furniture was exceedingly simple. There was a standing bedstead 'for the Fellow, supposing one of the occupants to be a Master of Arts; a 'trundle-bed' for the undergraduate, which during the daytime was pushed under the standing-bed 'of his superior; a 'leaden laver with a troughe or spoute to wasshe with'; a table, with forms or stools, not chairs; and a few shelves for their books and clothes. In many cases the walls were bare, the floors were of mud, and the roofs open to the rafters. Subsequently they were made more comfortable, and during the sixteenth and seventeenth centuries wainscot was generally introduced, and occasionally hangings of 'green say.' These luxurious additions to primitive simplicity were not, however, universal, and probably marked the presence of a wealthy or

luxurious occupant. The poet Gray is said to have been 'the first, and for a long while the only person in the University who made his rooms look pretty. He took care that his windows should be always full of mignonette or some other sweetly-scented plant, and he was famous for a pair of huge Japanese vases, in blue and white china.' Up to ten or fifteen years ago simplicity was the rule and not the exception; and even the fathers of the present generation would never have dreamt of decking out their apartments with the china and other knick-knacks which 'culture' now demands. Dress, independently of cap and gown, was formerly watched by the authorities with jealous care, and deviations from established custom summarily checked. At the beginning of the century, 'shorts of any colour, and white stockings, were the only regular academical dress,' gaiters being forbidden. In 1812 an order was made by the Seniors of Trinity and St John's that students who appeared in hall or chapel in pantaloons or trousers should be considered as absent. So late as 1815, Dr Mansel at Trinity threatened to put an undergraduate 'out of commons' – that is, to deprive him of the means of obtaining food from the college – for appearing in hall in trousers instead of breeches and gaiters. Shoes were worn on the feet; boots being especially forbidden. The change to trousers took place between 1820 and 1830. The older members of the University resisted the innovation, and Dr Proctor, Master of St Catharine's, who did not die till 1844, wore knee-breeches, when in full dress, to the last; and

Dr Chapman, Master of Caius, who died in 1852, always rode in breeches and top-boots. When the writer was an undergraduate, the Dean at Trinity constantly reproved those who wore their gowns over a light-coloured coat; and occasionally such unruly persons were sent out of hall to change the offending garment for one of a sober grey or black. Professor Pryme gives the following interesting account of the customs of his undergraduate time (1799-1803) in these matters:

'It was usual for the undergraduates, or at least the more particular ones, to dress daily for the dinner in hall in white waistcoats and white silk stockings, and there were persons who washed them for us, as things too special for a common laundress. There were two or three undergraduates who wore powder. The rest of us wore our hair curled. It was thought very rustic and unfashionable not to have it so. Wigs were still worn by the Dons and Heads, with two or three exceptions. Cory, the Master of Emmanuel, was, I have heard, the first to leave his off, complaining of headache.

Dr Barnes, of Peterhouse, preserved his to the last. In Mr Daniel Sykes's time, which was twenty years before mine, the Senior Fellows of Trinity wore wigs, and he was, as he told me long afterwards, concerned in a practical joke concerning them. There was a barber's shop just within the gate of Trinity, near Bishop's Hostel, where the Fellows were powdered and the wigs dressed. It existed even in my time. Sykes and some others bribed the barber one Saturday night, when he had the Sunday wigs to dress, to give them up; and getting out upon the library parapet placed

them on the heads of the four statues which face the hall. The next day the Seniors missing their best wigs were in a state of great excitement, and obliged to go to dinner in their old ones. Coming out of Hall into Neville's Court, and looking up, they saw them on the statues. The perpetrators were never found out.'

So late as the summer of 1832, Professor Pryme himself appeared at a dinner-party in his own house in nankeen breeches, tied at the knees with bunches of coloured ribbons, a blue coat with brass buttons, and a buff waistcoat.

College barbers have not been long extinct. The last was Robert Bendall of Peterhouse, who died in 1879. He used to come round the college in the morning, wake the men for chapel, and shave them – the lazy ones in bed. Dr Woodham of Jesus, who did not take his Master of Arts degree till 1842, has been heard to say that he has seen a hairdresser curl the Fellows' hair in the Combination Room before they went to the Bachelors' Ball. In the old statutes of Trinity the barber was on the foundation, like the cook. Most colleges had a barber's shop. At King's, each Fellow paid for his own shaving, but that of the Provost was defrayed by the college. Until the popularity of the Volunteer movement cast a military air over civilian manners, the cultivation of beards and moustaches was not allowed by the authorities. Dr Whewell set his face steadily against the practice; and so late as 1857 a scholar of Trinity, who was afterwards elected to a fellowship, having returned at the beginning of

the October term with these two ornaments on
his countenance, was requested by the Dean to
remove them. He was a good looking fellow,
and deeply deplored the loss of so important an
addition to his personal attractions. His regrets
found vent in song, and he published a new Rape
of the Lock, with which the Dean was so much
amused, that he requested a copy, and a version
in Latin elegiacs. A few of the lines are worth
quotation:

'Farewell I too little and too lately worn I Let the rude
breezes bear ye where they list: For this defied I the
chill dews of morn? In rain or sunshine ne'er a chapel
missed? 'Dean! is thy seat so lofty that its snows Have
sunk into thy heart and settled there? Can my beard
mar the heaven of thy repose? So great a man, and
such a little hair!'

The hours at which meals have been taken at
different periods have been curiously altered.
To begin with dinner. In 1550, dinner in hall
was at ten o'clock and supper at five. This was
in accordance with the general practice of the
country, where, as Holinshed says, 'The nobilitie,
gentrie, and students do ordinarilie go to dinner
at eleven before noon, and to supper at five,
or between five and six, at afternoone. The
merchants dine and sup seldome before twelve
at noon and six at night, especiallie in London.'
In the seventeenth century the hours had moved
on to eleven and six, except during Sturbridge
Fair, when supper was served at nine; and in the

next century we find Oxford students dining at twelve, to the great distress of a Conservative of that day, who notes in his diary, 'When laudable old customs alter 'tis a sign learning dwindles.' However, at Cambridge the hour of twelve was maintained till near the end of the century in all the colleges, and the students afterwards attended regularly at the disputations in the schools, which began at two. About 1785 the hour had been changed to one o'clock, and in some colleges to two o'clock in vacation. Next the hour became three o'clock, upon which alteration Dr Watson, then Regius Professor of Divinity, writing in 1818, thus laments himself:

'An evil custom has, within these few years, been introduced into the University, which will in its consequences destroy our superiority over Oxford, and leave our scholastic exercises in as miserable a state as theirs have long been. It is the custom of dining late. When I was admitted [November, 1754], and for many years after, every college dined at twelve o'clock, and the students after dinner flocked to the philosophical disputations which began at two. If the schools either of philosophy or divinity should ever be generally destitute of an audience, there will be an end of all scholastic exertions. I remember having seen the divinity schools (when the best act – by Coulthurst and Milner, Arcades anibo–was keeping that I ever presided at, and which might justly be called a real academic entertainment), filled with auditors from the top to the bottom; but as soon as the clock struck three, a number of Masters of Arts belonging

to colleges which dined at three slunk away from this intellectual feast; and they were followed, as might have been expected, by many undergraduates. I say, 'as might have been expected,' for in all seminaries of education relaxation of discipline begins with the seniors of the society.'

It is always amusing to get the same event described from two different points of view, and therefore we will digress for a moment to quote Gunning's description of this act, at which he was present:

'The first opponent was Mr Coulthurst, of Sidney (afterwards Vicar of Halifax); he and the Respondent had been repeatedly Moderators and Examiners, and in the discharge of the duties of those offices had displayed considerable talent and attainments. In other respects no two men could be more dissimilar. Milner was a man of immense size, with stentorian voice; Coulthurst was remarkably small, with an extremely low but distinct voice. Milner began his answer before the other had propounded his argument, and Coulthurst continued his argument after it had been answered. In point of fact, they both spoke at the same time, and neither paid the least attention to what the other said. The Professor two or three times made an ineffectual attempt to enforce the acknowledged laws of disputation, but they took no notice of his remarks, although uttered in his usual solemn and dignified manner. He consequently resumed his seat in despair, uttering only the two words, Arcades ambo,' and they were allowed to finish the disputation in their own way.'

On another occasion Dr Watson drew public attention, in a very amusing manner, to the real reason of gentlemen leaving the schools in such haste; namely, in order to reach their college hall in time to save the fine – a bottle of wine – that was then the invariable penalty for appearing five minutes after the bell had ceased ringing. The Vice-Chancellor's weekly dinner-parties were at that time given on Sundays, at half-past one, and his whole company went with him to St Mary's, where the sermon then began at three. Early in the present century the dinner-hour advanced to four o'clock, at which it remained until a few years ago.

When dinner was early there was supper in the hall – first at six or seven, and afterwards at a quarter before nine. The meal, however, was not a favourite one, as undergraduates preferred to sup in their own rooms, as more sociable. They used to form themselves into parties, and each man ordered the dish he fancied to be carried to the room in which the entertainment was to take place. The host supplied bread, butter, cheese, and beer, with a 'beaker' or large teapot full of punch, which was kept on the hob. Wine was not allowed.

As these parties used to take place at about eight o'clock, they could not have been very different from a plain dinner at the present day.

The dinner at three or four o'clock was a great inducement, especially among the Fellows, and in winter, to cultivate the habits of deep drinking that were, unfortunately, so common

at the beginning of the century. At the meal itself little or no wine was taken, but at its close the company retired to the Combination Room, where they not unfrequently sat till supper-time, after which meal those who were sober enough had 'beakers' in their own rooms; and so to bed, as Mr Pepys would have said. The twelve days of Christmas were, of course, kept in a specially exuberant fashion; songs, toasts, and sentiments, were given in Combination Rooms, and I have heard Professor Sedgwick relate how fortunate the Fellows of Trinity once thought themselves in securing the society of an Irish captain during that season, whose comic humour and vocal powers were of no ordinary kind. The practice of giving toasts was always observed on feast-days in Combination Rooms, and extended to private wine-parties, with the same observances that Sheridan has introduced into the supper scene in The School for Scandal. 'The host,' says Professor Pryme in his Reminiscences, 'named a Vice-President, and toasts were given. First, a lady by each of the party, then a gentleman, and then a sentiment. I remember one of those latter – "The single married, and the married happy." Some of them were puns, and some not very decorous. Every one was required to fill a bumper to the toasts of the President, the Vice-President, and his own.' How formal this system must have been, and how destructive of all rational conversation! At the parties of some of the 'fastest' men, it was not unusual to break the feet off the glasses in order that bumpers might be drunk to all the toasts;

and so long as a single bottle of wine remained in the host's cellar his friends continued to drink, no matter how late the hour might be. Early in the present century, however, a resolute effort was made by a few popular men to stop all attempts to force the unwilling to drink, to be temperate themselves, to separate at chapel time, and not to return afterwards. These rules were soon accepted generally, and uproarious wine-parties ceased. When the writer was an undergraduate it was the custom to give one in each term, to which a man asked his entire acquaintance, quite without reference to the capacity of his rooms to contain them. Those who came early got seats – those who did not remained standing – and after a decent interval went away. Sometimes – if the host 'kept' in lodgings – he engaged a band of music. Itinerant musicians used to walk the streets, and when they saw that a wine-party was going on anywhere, sent upstairs to offer their services. The whole affair was very harmless, but very dull. The custom has died a natural death of late years, since a later hour for the hall-dinner has been accepted in most colleges.

A journey was not a thing to be lightly undertaken sixty years since, and therefore a great many of the Fellows, especially those whose homes were in distant parts of England, resided in Cambridge all the year round. For the same reason visits from strangers were rare events. General society, too, could scarcely be said to exist at Cambridge during the first quarter of the century. Hence the same persons were in

the habit of meeting, day after day; and, as a natural consequence, treated each other with a rough-and-ready familiarity. Plainness of speech, to an extent that would nowadays shock ears polite, characterised ordinary conversation; and humorous stories were 'Elizabethan' in their phraseology. Personalities, such as would not now be tolerated anywhere, were freely indulged in; and 'satires or lampoons on particular people,' like Sir Benjamin Backbite's 'little productions,' circulated in the same manner,' by giving copies in confidence to the friends of the parties.' One of the principal authors in this style was Lort Mansel. Many of his epigrams, though he was Master of Trinity, and Bishop of Bristol, need the decent obscurity of a learned language; but one or two may be quoted. The following was on the marriage of the Master of Corpus Christi College (then called Bene't College), a very thin man, with an equally thin lady:

Saint Paul has declared, that persons though twain
In marriage united one flesh shall remain;
But had he been by when, like Pharaoh's kine pairing,
Dr Douglas of Benet espoused Miss Mainwaring,
The Apostle, methinks, would have altered his tone.
And cried, These two splinters shall make but one bone

The following satirised the conduct of Hinchliffe, Master of Trinity and Bishop of Peterborough, who put a wretchedly bad singer into the college choir because he had a vote for Peterborough:

A singing-man and yet not sing I
How justify your patron's bounty?
Forgive me; you mistake the thing:
My voice is in another county!

Mansel, after he became Master of Trinity, was a grand personage, full of his own importance, and disdainful to those whom he regarded as his inferiors. It is to him that Byron refers in his Thoughts suggested by a College Examination:

High in the midst, surrounded by his peers,
Magnus his ample front sublime uprears;
Placed on his chair of state, he seems a god,
While Sophs and Freshmen tremble at his nod.

The following story affords a good illustration of his character. Sir Busick Harwood, Professor of Anatomy, between whom and Mansel there had been a feud of long standing, gave a breakfast in the garden of his house, near Emmanuel College. Being anxious to show every consideration to the great man, he placed a young nobleman, who was at the time an undergraduate of Trinity, at the same table, unconscious or oblivious of the fact, that it was sacrilege to bring a human being so low in the social scale of the University 'between the wind and his nobility.' Before breakfast was half over, Mansel got up suddenly, ordered his carriage, and took his leave. Next morning Lady Harwood entreated her husband to go to Trinity Lodge and inquire whether he was ill, or whether they had unconsciously offended him in any

way. Sir Busick, most unwillingly, acceded to her urgent solicitations. He found Mansel in his study, looking, like Mr Nupkins, 'gloomily grand, and savagely vexed.' 'I have come, my Lord, on the part of myself and Lady Harwood, to inquire' began the Professor. Before he could finish his sentence Mansel thundered out, 'Sir Busick, I am a peer of the realm, God knows how unworthy 'God knows, and so do I,' said the other, and vanished.

In the sixteenth and seventeenth centuries Tutor and Pupil stood in a close and even affectionate relation to each other. We have seen that occasionally they occupied the same chamber; and it must further be remembered that the number of students proceeding to degrees was infinitely smaller than at present, so that a tutor could not only educate all his pupils, but understand their characters by personal intercourse. Sir Symonds d'Ewes, who was admitted at St John's in 1618, speaks frequently in his diary of Mr Richard Holdsworth, whom he styles 'my loving tutor,' and records his gratitude for his kindness in taking walks with him and treating him as an equal. By degrees those relations were done away with. Various reasons, such, for instance, as the following, have been assigned for the change. Older men ceased to share rooms with undergraduates; increase in numbers made intercourse ceremonious and insincere; political differences brought about suspicion and estrangement. Whatever may have been the cause, the broad fact remains that little by little a spirit of donnishness crept into the University, and soon

reigned supreme there. For a century or more the older and the yoimger men saw very little of each other. A fellow-commoner now and then sought the society of the Fellows whom he met at the high table; but more frequently he regretted his isolation from the men of his own age and standing, and made his escape as soon as dinner was over. This change of feeling was another instance of the way in which the Universities reflect the tone of the country. In the last century a man addressed his father as 'Sir,' and, so far as we can judge from contemporary literature, regarded him with fear, and not unfrequently with dislike. In the first half of the present century the new literary tastes and new political opinions that became prevalent among young men, notwithstanding the almost proverbial Toryism of young Englishmen, made the breach wider still. A college tutor, popularly supposed to stand towards his pupils in the relation of a father, came to know so little about them, that the following anecdote is not incredible. One of the tutors of a large college desired his servant to go and invite a pupil, whom he had not seen for some time, to take wine with him after hall. 'Mr So-and-so, sir? He died three terms ago.' 'You ought to tell me when my pupils die,' replied the Don. We do not vouch for the literal accuracy of this incident, but it illustrates the estrangement that existed between those who ought to have been teachers and those who should have been taught. It is almost needless to add that unruliness and excess became the rule, rather than the exception; and

sixty years since the morality and the behaviour of the young men at the University was not of the best. The famous – or perhaps we should rather say infamous – letter of Mr R. M. Beverley to the Duke of Gloucester (then Chancellor of the University), published in 1833, had, no doubt, a germ of truth beneath the gross exaggerations and wilful misrepresentations with which it is filled. The pamphlet is now almost forgotten, or remembered only for the manly and crushing reply that it elicited from Professor Sedgwick – a denunciation that Junius himself might not have disdained to sign. At the time of its publication, however, it made a great noise, and the numerous replies to it that were published are a proof that it was not all invention. If a malevolent scribbler were to write such an article in such a style nowadays, not a soul would think it worth his while to answer a word.

Many causes have contributed to bring about a better state of things since; and nothing could be healthier than the feeling that now exists between authorities and undergraduates. As an instance of the resentment that was sometimes excited before this excellent consummation was effected, we will refer to the amusing squabble about attendance at chapel at Trinity in 1838. At the beginning of the Lent Term in that year, the Master and Seniors had agreed 'that all Undergraduates, Scholars, and Foundation Sizars, do attend chapel eight times at least in every week, that is, twice on Sunday and once on every other day,' on pain of sundry penalties; and finally, after three formal

admonitions from Dean, Tutor, and Master, 'the offender shall, ipso facto, be removed from the College, either entirely or for one or more Terms.' This novel severity was met by a singular expedient. A number of men enrolled themselves as 'The Society for the Prevention of Cruelty to Undergraduates'; one or more of their number made a point of attending every chapel and noted the attendance of the Fellows. The result was published in a weekly paper, which was circulated in Cambridge, and even in London, where it found its way into the Clubs and some of the newspapers. The remarks that these impudent youngsters appended to their weekly records are very entertaining. On February 24th, the second week of the existence of the institution, we read:

'The Society, though gratified to find that their labours have had the effect of producing more regularity on the whole, among the Fellows, will not relax in their endeavours to promote the cause of Religion. Eight Chapels are all that they require to be kept, and should any Fellow, through illness, be unable to attend, on sending a note to the Secretary of the Society, he Avill be excused.'

On March 3rd it is announced that:

'A prize for general regularity and good behaviour when in Chapel has been instituted by the Society, who are as anxious to reward merit as they are to punish immorality. But, whilst they thus wish to instil into the minds of the Fellows those Religious feelings which,

owing to a bad education, they may possibly be without, the Society most distinctly declare that they shall not be guided merely by an outward show of religion. It is not, therefore, enough to go merely eight times a week to Chapel, and when there to utter the responses so loud as to attract attention, or otherwise disturb the prayers of Undergraduates. Such conduct will at all times be severely punished. But there will be a general examination of tlie Fellows at the end of each term, when they will be classed according to their merits.'

On March 10th the following note appeared:

'The Society regret much that during the last week great laxity has prevailed among the Fellows in general with regard to their attendance in Chapel. This is the more to be lamented, as they had been for the two previous weeks so much more regular than usual. This irregularity cannot proceed from ill health, for they have been constantly to Hall, although they are not compelled to go there more than five times each week. The Society, however, still hope that in the ensuing week they will be able to make a more favourable report both of their attendance in Chapel as also of their good conduct when there. As was before stated, any Fellow who shall, owing to any wine-party, or other sufficient reason, be prevented from attending, will be excused on sending a note 'previously to the Secretary of the Society, and his absence will be counted as presence.'

Then they drew up an average of the attendance of each Fellow for a month, in a tabular form, with

the average for each of the four weeks exactly calculated. Of the seventeen Fellows one has zero appended to his name, another '75, and even the three tutors do not exceed 6l, 6, and 4. No wonder we find the footnote, 'Why then do they not set us a better example?' This observation went to the root of the whole matter. The Fellows did not so much as attempt to understand the Undergraduates. It would not be difficult to find individual instances of friendship and sympathy; but as a general rule the two bodies were opposing forces who regarded each other with suspicion and dislike. 'The place would be agreeable enough to live in, were it not for the Town and the Undergraduates,' said a learned Professor. But to return to Trinity. At the end of the sixth week the Masters and Seniors altered their regulations, and announced that they would be content with six chapels in each week instead of eight. The undergraduates on their side announced that the 'Chapel Lists' would be discontinued; and as a last shot at the now retreating enemy, they published a Class List, in the form used at a college examination, in which the Fellows were divided into four classes, according to their number of attendances. Two names appear in italics below the last class, as not worthy to be classed at all. The first class contained only three names: those of the Senior and Junior Dean, and of Mr Perry, afterwards Bishop of Melbourne. The former, being obliged in virtue of their office to attend twice daily, were held to be disqualified for the prize with which it was intended to reward the most regular attendant

at chapel. Mr Perry, therefore, who had attended sixty-six times during the period of examination, received a copy of the Bible, handsomely bound, and the following note was appended to the last publication of the Society:

'The Prize Medal for regular attendance at chapel, and good conduct when there, has been awarded to Mr Perry, who has passed an examination highly creditable to " himself and family." He was only 18 marks below the highest number which he could possibly have gained. It is, therefore, to be hoped Mr P. will be more regular and do still better next term. With respect to the two Gentlemen who are not classed, the Secretary need hardly say that he does not envy them their feelings on the present occasion.'

Our sketches of University life and manners would be incomplete without some reference to the Heads of Colleges. In an earlier chapter we described the position of the Head before the Reformation when he was in reality, and not merely in name, the supreme director of the body corporate over which he presided. After the Reformation, when permission to marry had been conceded, and the simple Master's chamber of earlier days had been enlarged into a comfortable, not to say luxurious, Lodge, the Master of necessity lived apart from the Fellows of his college. The government of the University was, to a great extent, in the hands of the Heads, who, in the case of numerous offices, had the right of nominating two candidates for election,

of whom the Senate chose one; and, moreover, as assessors to the Vice-Chancellor, they acquired by custom a far wider power than had been conceded to them by statute. Nothing could be imagined better in theory than that the persons who represented individual colleges should form the united government of the University; and so long as the Heads associated with the Fellows in daily intercourse the scheme probably worked well. But after they began to live apart, they had fewer opportunities of appreciating the ideas and feelings of even their own colleges; and as these became larger it became impossible for the Head to perform the multifarious duties that had been imposed upon him in simpler times. Consequently the Heads were constrained, by the necessities of their unfortunate position, to separate themselves from the rest of the University, and to associate only with one another.

This preface is necessary for the right understanding of the condition of Society which we purpose briefly to illustrate. What we are about to say refers, it must be remembered, to a state of things which died a natural death with the Elizabethan statutes. Moreover, the persons to whom our reminiscences allude have all passed away, and these sayings and doings have become the common property of the public.

Sixty years since society at Cambridge was divided broadly into two classes – those who were Heads of Houses and those who were not. The former were the aristocracy; and no Grand Duke of a minute territory, no cathedral dignitary, no

Head Master of a great school – no, not even Dr Keate himself in his most aristocratic days – was ever hedged about with a more awful dignity, or exacted a more implicit obedience. 'You ought to remember, sir, the immeasurable distance between an undergraduate and the Master of his college,' said Dr Mansel, on a certain occasion, to an unlucky youngster who ventured to address him. For this speech there might have been some justification; but there was none for the spirit of arrogance and self assertion that was the peculiar characteristic of those seventeen oligarchs towards even the oldest and ablest of the academic body. From the hour that an individual became Master of his college, he was raised (in his own estimation) into a higher region, whence he looked down with contemptuous pity on the less-favoured many, oven though some of them might have been his oldest and most intimate friends. Damon and Pythias might have taken their daily walks together along vhe Trumpington Road for many years; but should Damon be elected Master, he would next day give Pythias two fingers, and address him formally as Mi\ Pythias in conversation or in writing. When a Head of a College gave a dinner-party sixty years since, he invited Heads only. That exceptions to this rule were so rare that they may be neglected in a general statement of the characteristics of the Order. If such an invitation was issued, it was a royal command, and not even the death of an intimate friend was admitted as an excuse. This exclusiveness survived to comparatively modern

times to such an extent that even after a more general intercourse was permitted, and Heads had begun to visit Professors, the only son of the host was not allowed to dine at his own father's table because, forsooth, the Master of his college was expected there as a guest! At the beginning of the present century. Dr Mansel had condescended to unbend somewhat, and to give less solemn entertainments. That august person had six unmarried daughters, and possibly some thoughts of their settlement in life may have influenced him. Professor Pryme relates that evening parties at Trinity Lodge were not uncommon at which music was given, and sometimes 'a dance was improvised, for which the Master would himself turn an organ.' That, however, was in 1809; but twenty years later a far greater exclusiveness had become the rule. So complete was the social severance between the Heads and the rest of the University that considerable curiosity was felt by each half of the academic world as to the sayings and doings of the other. 'What do you talk about in your society!' said the wife of a Head to the wife of a Professor in 1819, 'is it amusing?' Just about that time, however, a bold innovation was made, which stirred the University to its depths. Mr Serjeant Frere had just been made Master of Downing, and, being an enlightened person who had passed most of his life in London, saw no reason why the good folks of Cambridge should not amuse themselves according to the fashions of the metropolis. So Mrs Frere, who sang divinely, gave musical parties in the Lodge itself, and

tableaux vivants also, which were much admired; and at last (I vow my hand shakes so with horror at the very thought of it that I can hardly make my pen write down the awful profanation) she got up The Rivals and The Critic in the College Hall! One of her first evening parties took place after a solemn symposium given to an assemblage of Heads. They had not been made aware of what was about to happen, and it was remarked afterwards by the wife of one of them, 'Some people came in in the evening – of course we went away.'

University society is subject to very frequent changes, as the older members leave and the younger take their places. In the second quarter of the present century it was more than usually brilliant. The long dinners in College Hall had been given up, except on rare occasions of high festival, and the Fellows delighted to go into general society of an evening. There were musical parties, under the auspices of Professor Smyth and Mrs Frere, dramatic entertainments, sparingly and somewhat grudgingly permitted, and numerous dinner-parties, enlivened by conversation which ranged from the deepest to the lightest themes. Men of the highest literary and scientific distinction – such men as Dr Whewell, Dr Peacock, Mr Thirlwall, Dr Turton, Mr Hare, Mr Worsley, and Professor Sedgwick – drew each other out, capped each other's stories, or took opposite sides in argument. At times, especially if Dr Whewell were present, conversation became a monologue. It was said by Sydney Smith

that 'Science was his forte and conscience his foible.' He delighted in taking up a subject, and delivering his opinions upon it, while the rest of the company listened respectfully. Some might be disappointed of an opportunity for placing their own witticism, or for urging their own views; but the speaker handled his theme in so masterly a style, that his hearers accepted his despotic ways without a murmur.

Once, and once only, says tradition, an attempt was made to dethrone him. A party of the Fellows of his own College got up carefully the subject of Chinese music, and adroitly turned the conversation towards it in the Combination Room. Mr Whewell joined in for a while, and then became silent, while they went on, delighted at the thought that for once the conversation was in their own hands. The triumph, however, was short-lived, for Whewell presently thundered out, 'Ah! I see you have been getting up an article I wrote some years ago in an Encyclopaedia; but I have altered my views since then.' Miss Caroline Fox tells us in her charming diary that when Whewell met them in Cornwall in 1859 her father 'got from him a formal contradiction of the choice story about Chinese music, which was a pity, but he says he never wrote on the subject, only on Greek music' The imaginary incident, however, is very characteristic of Whewell's astonishing familiarity with all sorts of out-of-the-way subjects; and, it may be added, of his habit of laying down the law in an imperious fashion which made him extremely unpopular with those who did not understand him. Professor

Sedgwick did not engross the conversation as Whewell did. His own geniality inspired those with whom he came into contact, and any party at which he was present was sure to go off well. He had a really marvellous aptitude for storytelling. The adventures of Elizabeth Woodcock, for instance, who was buried in the snow near Cambridge in February 1799, for eight days, grew, in his narrative of them, into a wonderfully dramatic story, humorous and pathetic by turns; and his recollections of his earlier days were as picturesque as they were amusing. One of these, relating to Mr William Pugh, shall be given in his own words:

'Mr Pugh, before he had been Fellow of Trinity for long (he was elected about 1790) was deeply affected by the horrors of the French Revolution. He was a man of great reading and studious habits; and, among other things, was engaged upon the catalogue of the printed books in the University Library. There, instead of reading only the title pages, he read the works themselves through, and thus, while he got on slowly with the catalogue, he laid up a vast store of knowledge, especially in the pamphlets published at that time; so much so, that when Dr Parr dined in Trinity College some thirty years afterwards, Pugh, though he had been mad in the interval, and for twenty years had never opened a book, was yet able, from his excellent memory, to quote pages and pages from the pamphlets of that time. Pugh and Dr Parr were of opposite politics; Pugh was a strong Conservative, Parr an equally strong Whig; so that when the former

was seen to take the chair as Vice-Master, with Parr
on his right hand, every one expected an unpleasant
scene. But, luckily, the conversation turned upon the
literature of the early years of the French Revolution,
with which Parr was equally well acquainted. So for
hours and hours they capped each other with stories
and quotations; till at last Pugh referred to a pamphlet,
"which," said he, "I wonder had so little influence, and
so little popularity: for I was very much struck with one
passage in particular; and if you woiild like to hear it, Dr
Parr, I think I can repeat it to you." He then proceeded
to repeat without hesitation about a page and a half,
after which he rose to go, and turning to Dr Parr, said,
" I thank you, Doctor, for the very pleasant evening we
have had together; and as for that pamphlet, I think
you know more of the author than I do." So saying, he
left the room. When he was gone, Parr said, " I was the
author of that pamphlet, but it fell dead. I have never
read it since, and I give you my honour that I could
not have repeated a line of it myself." ' Well, about
his madness. For a long while he was very strange; he
dreaded the society of everybody; he never left his
rooms for any purpose whatever; he would not let his
bed-maker enter them, but, at a stated hour every day,
used to open the door a little, take in his breakfast,
and slam it to again. One morning, very early, he
was seen by the porter to walk across the court in a
mistrustful manner, looking behind him, and to the
right and left, with the utmost circumspection, and so
go into the Bowling Green, which in those days was
not closed with a grating as it is now. On his shoulders
he carried a large white bundle. This he was seen to
carry to the terrace overlooking the river, and there

pitch it over into the Cam. Search was made for it, and it was fished up. It was found to contain all his dirty linen, remains of his food, etc., which had become too foul to be endured longer. This was not thought sufficient proof of insanity to warrant his being sent out of residence. Soon after, however, the town was thrown into consternation by the frequent breaking of the lamps. Night after night several were found broken, no one knew by whom. The Mayor offered a reward, but still the culprit remained undetected. At last the College porter observed that Pugh was in the habit of going out after the gates were closed. So a servant was set to watch, and, the next time Pugh went out, followed him at a distance. He went down Jesus Lane, and, when he came to the Common, turned to the left along Jesus' Ditch. There he presently went down to the water's edge, and, from among flags and weeds, brought up a long stick. This he seized, and hurried back to the street. No sooner had he got there than the frenzy seemed to seize him. He gnashed his teeth, and rushed along like a madman. Presently he caught sight of a lamp, made for it, and exclaiming with a loud oath "You are Robespierre!" dashed it to pieces with his stick. So he went on with the others, crying out "Dan ton!" "St Just!" and other names, till he had broken six or eight. Then he returned to the ditch, hid his stick, and made his way back to College. After this he was requested to leave, and put under the care of a keeper. He recovered, however, and returned to College, and, though he had still a somewhat wild look, behaved with ijerfect propriety. His judgment was considered extremely good, and in the Fellowship Examination his opinion was preferred to that of most

other examiners. His memory was such that he could trust to it when others had to refer to the author, as in the case of the Greek tragedians.'

With this anecdote our reminiscences of the Social Life of Cambridge sixty years since must come to an end. When those of the present decade are written the annalist who takes the subject in hand will have a very different picture to draw. He will find the number of undergraduates more than doubled, and engaged in a multiplicity of studies and interests, which offer a lively contrast to the sameness of the course along which their ancestors were compelled to plod. He will have to notice, too, the realisation of the dreams of that Princess whose educational views were set forth by the Poet Laureate; and though there are as yet no 'sweet girl graduates' tripping to the Senate House on Degree Day, there are signs which indicate that even that alteration may be nearer than some suppose. In the opinion of many excellent well-wishers to Cambridge the death-knell of her fame as a place of education would be sounded if this were to be brought about, or if in sundry other ways that we need not further particularise she were to accept changes that begin to be demanded, with no uncertain sound, from without. We do not share these apprehensions; we believe firmly that

'The old order changeth, giving place to new,
And God fulfils Himself in many ways,
Lest one good custom should corrupt the world.'

The Westburn Sugar Refineries Ltd.

Greenock

Why use "WESTBURN" Golden Syrup?

BECAUSE

Of its wonderful purity and rich quality.

BECAUSE

Money cannot buy anything better.

BECAUSE

"WESTBURN" is a home-produced article, and you are helping to employ local labour.

BECAUSE

"WESTBURN" is an article that

BORWICK'S

BAKING POWDER

A Good Plain Cake

Mix well together 1 lb. of Flour, 2 large teaspoonsfuls of **Borwick's Baking Powder,** a little Salt and Spice, and ¼ lb. of Sugar, rub in 6 ozs. Margarine, add 6 ozs. of Sultanas, 2 ozs. of Currants, and 1 oz. of Candied Peel. Moisten the whole with 1 Egg and 1 teacupful of Milk previously beaten together. Bake in a quick oven for about 1¼ hours.

Scotch Drop Scones

8 ozs. Flour.
1½ teaspoonsful **Borwick's Baking Powder.**
2 ozs. Margarine.
1 tablespoonful Golden Syrup.
Pinch of Salt.
A little Milk.

Sieve flour, baking powder, and salt into a basin, rub in the margarine with the tips of fingers, add the golden syrup and sufficient milk to make a light dough. Drop in small heaps on a Scotch gridiron, place on the top of the stove, and cook on each side.

Plain Raisin Pudding

Take 1 lb. of Flour and mix with it 2 teaspoonsful of **Borwick's Baking Powder,** ½ lb. of Stoned Raisins, 2 teaspoonsful of Demerara Sugar. Mix with enough water to form a moist pudding, put into a greased basin, tie in a cloth, and boil for 2 hours.

Are *YOU* using the following?

" PETERKIN "

REAL EGG CUSTARD POWDER

" The finest Custard Powder obtainable."
—*Grocers' Journal*, 2nd July, 1921.

" PETERKIN " *Blancmanges*

In all popular Flavourings.
Delicious—Dainty—Delightful.

" PETERKIN " *Patent Corn Flour*

Guaranteed perfectly pure, wholesome
and nourishing — very easily digested.
Excellent for thickening Soups, Sauces, etc.

" PETERKIN " *Self Raising Flour*

Milled from the finest wheats in the world.
Makes delicious Cakes, Pastry & Puddings.

*All the foregoing products manufactured
under ideal conditions in Scotland by*

THE "K.O." CEREALS CO. LTD.

LONDON GLASGOW GREENOCK

ECONOMY IN YOUR KITCHEN MUST APPEAL TO YOU

MARMITE

IS THE EXTRACT YOU SHOULD USE FOR MAKING AND ENRICHING ALL

Soups, Sauces, Stews Gravies, Sandwiches, etc.

Note these Points.

1.—MARMITE is low in price.

2.—MARMITE is most economical in use.

3.—MARMITE, owing to its richness in vitamines, is good for you and your children.

4.—MARMITE increases vitality and thus staves off influenza and chills.

5.—MARMITE keeps the strong fit and builds up the weakly.

6.—MARMITE taken last thing at night induces refreshing sleep.

Note these Prices.

1 oz. jar **6**d.	4 oz. jar **1/6**
2 oz. jar **10**d.	8 oz. jar **2/6**
16 oz. jar **4/6**	

L

The Victorian Traveller's Guide to Norwich

Before Lonely Planet, this book was the essential
accompaniment to any Victorian gentleman or lady's
trip to one of the foremost cities of the United Kingdom.

978 1 4456 4357 1
160 pages

Available from all good bookshops or order direct
from our website www.amberleybooks.com

The Victorian Traveller's Guide to Canterbury

Before Lonely Planet, this book was the essential
accompaniment to any Victorian gentleman or lady's
trip to one of the foremost cities of the United Kingdom.

978 1 4456 4307 6
160 pages

Available from all good bookshops or order direct
from our website www.amberleybooks.com